IMAGES
of America

CAMARILLO
STATE HOSPITAL

Happy Reading, Evelyn

IMAGES
of America

CAMARILLO
STATE HOSPITAL

Evelyn S. Taylor and Mary E. Holt

ARCADIA
PUBLISHING

Published by Arcadia Publishing
Charleston, South Carolina

Printed in the United States of America

Library of Congress Control Number: 2019930779

For all general information, please contact Arcadia Publishing:
Telephone 843-853-2070
Fax 843-853-0044
E-mail sales@arcadiapublishing.com
For customer service and orders:
Toll-Free 1-888-313-2665

Visit us on the Internet at www.arcadiapublishing.com

To the staff and patients of Camarillo State Hospital:
we thank you for allowing us to be a part of your special history.

CONTENTS

ACKNOWLEDGMENTS

The authors gratefully acknowledge the Bancroft Library; the California State Archives; the City of Thousand Oaks Library, in particular, Jeanette Berard and Heather Cousin; the California State University Channel Islands Archives; and the National Archives and Records Administration for their approval in the reproduction of photographs and documentation. We would like to thank Andrea Howry and Colleen Cason from the *Ventura County Star* for their continued coverage on the hospital's history.

We offer a special appreciation to the following former hospital employees for their willingness to share information: Suzan Barosso, Susan Gransee, Valerie Harris, Howard "Buster" Smith, and Sherry Warrick. We would also like to bestow the title of honorary "archivist" to Judy Lucas, in gratitude for documenting the early years.

Our debt of gratitude extends to Anthony Casello for his submission of photographs in memory of his mother, nurse Patricia "Patty" Casello; Suzan Barosso, in memory of her daughter Megan Barosso; and Barbara Price, in memory of her brother and firefighter Michael Gregory.

Evelyn Taylor would like to thank Michael Hall for his unconditional support in, well, everything; Matt Cook, for his advocacy in this opportunity for her; Diana Morgan and Amy Saban, for giving her the weekends off to write; and her friends and coworkers, who have endured quite a bit of rhetoric on this topic. Lastly, Evelyn remains forever thankful to her mom and dad for saying "yes" instead of "no" when she asked them if she should quit her paralegal job and go back to school.

Mary Holt would like to thank her beautiful daughter, Shelby Holt, whom she dragged from one abandoned location to another, enduring her mother's passion for photography; Sydney A. Schultz, for lugging her camera and laptop everywhere and always supporting her every endeavor; and finally, to her mom Helen and sister Cindy, for simply being who they are and always there for her, no matter what.

Courtesies for the images are abbreviated for the following organizations: California State Archives (CSA); the City of Thousand Oaks, Thousand Oaks Library, and the *News Chronicle* (TO); California State University Channel Islands Archives (CSUCI); National Archives and Records Administration (NARA); and Mitch Stone of San Buenaventura Research Associates (MS).

INTRODUCTION

I distinctively remember driving in 2000 along the entrance to the university on the former Camarillo Street, now University Drive, for my initial interview as the university's first archivist. I was excited, of course, and nervous. I had just graduated with my first master's degree (CSU Northridge and later, CSU San Jose) and wanted so desperately to have a job that I actually went to school for. Other than hearing through the grapevine that it was the original Camarillo State Hospital, I really did not know anything about its history. I am not a California native, so I only knew that maybe, just maybe, it was *the* "Hotel California." Turns out it wasn't, but it was still literally out in the middle of nowhere. Fields and fields of produce winked at me, and the whiff of onion came through my car window. Surrounded by tan mountains, blue sky, fluffy white cloud puffs, and grounds littered with purple jacaranda tree leaves, the environment was quiet and serene. The campus, then California State University Northridge at Channel Islands, seemed to be on the brink of something. Something great was about to happen, and, hopefully, I would be a part of it.

After a rousing round of interviews, I was hired as a project archivist for the time being, and that was fine with me. I had been given a gift, although I did not know it at the time, and that gift was history. Despite the fact that the song actually has nothing to do with the hospital, "Cam," as it was affectionately called, will forever be attached to one of the Eagles' greatest hits. It is among one of the most magnificent examples of a legend, but as with many myths, there is a historical foundation, although perhaps not very satisfactory to those seeking to attach ghosts to every hallway of the notable Bell Tower.

In its heyday, Cam covered 750 acres and housed over 7,000 patients. It was a "small town," and no small town is ever without some issue at some point in time. However, as any specialist in the psychiatric field will tell you, Camarillo was cutting-edge and extremely progressive in the way that it viewed, treated, and cared for its patients. This is exactly what made its closing so very difficult on patients, families of patients, and employees. In fact, well after the doors were locked, the wildlife took over, and the patients were settling into their new environments, the staff thought about their patients. They knew Cam was unique. But I digress; let us go back to how the hospital collection came to me in the first place.

About a year after I was hired, former employees of the hospital decided to have a reunion near the old Hub (former "Cantina" and "Canteen") building, which served burgers and fries and is now El Dorado Hall. I was very curious and wandered over to talk to people about what the hospital was like when they experienced it. My very first impression was how happy and sentimental everyone was; the comradery was obvious. I began to chat with three little old ladies, and two of them began to weep a bit, describing how much they missed their patients and how they always thought of them. I understand something now that I did not understand then. The majority of patients (no matter what age or disability) at Camarillo had no visitors, ever. Their custodians, doctors, nurses, physical therapists, psychiatric technicians, teachers, etc., were the only people they saw on a regular basis, those who took care of them and looked

after them. Well, that was a monumental moment for me. Maybe "the Snake Pit" was not what it was made out to be.

After two years, I was fully and functionary permanently employed. Into my third year, a group of former hospital employees who were by now employed at the university came to my office one day and said, "Hey, we have something to show you." Well, who couldn't resist that invitation? Off we went, walking up the hill toward the original administration building. We ended at the old Receiving and Treatment Building, better known as "the hospital building" (our library now). This building at the time was akin to something out of a horror movie, with flashing lights, long dark hallways, mazes, and unidentifiable sounds coming from nowhere. We stepped into the elevator and out into the basement. They led me to a little broom closet and opened the door. Inside were 10 or 12 storage boxes. "These are for you," they said. "We know that the students will want to know about the hospital." Inside the boxes was a smattering of every type of hospital literature that you could imagine. To say that it was a mishmash is an understatement. As the units closed, employees gathered the items left behind by their comrades. I will always be thankful to those employees and to the current university employees who keep their eyes open for anything hospital-related. They keep the torch lit.

In the most random places, I meet individuals who experienced the hospital as a community member in various capacities—sometimes as a child or teen. They always have fond memories of singing in a chorus or marching in a parade. But it is the unusual and unexpected story that always makes me smile. I had not been at the university very long when a young man came to see me. He was working on the construction of University Glen (the apartments near where the old staff housing was located) and was curious about the university. He told me that his family had a ranch nearby and how, sometimes, the patients would escape and meander over to their property. In the middle of the night one night, his dad heard their bull snorting, and it did not sound good. A patient was inside the pen and petting the bull like a puppy, only he called it "kitty." The dad telephoned the hospital police, and over they came. Thankfully, no one was gored. That was life at the hospital.

Camarillo State Hospital officially closed July 1997. Four months earlier, in March, two parent groups filed a lawsuit against the Department of Developmental Services, alleging that closure would cause irreparable harm to the patients. It resulted in an order that the hospital would not close until the state ensured that the patients would receive comparable care at other facilities. That was the best that anyone could hope for. What is ironic about the closing is that people on both sides of the fence fiercely and passionately believed that they had the most humane solution. What they failed to comprehend was that decades before, the decision had already been made. And once that ball began to roll downhill, there was no stopping it.

I am not an expert by any means or stretch of the imagination on mental health, so I wholly encourage readers of this book to research this vast and complicated subject. Enough time has passed so that there is more than adequate documentation debating the impact of the closure of state hospitals across the country.

From my research, I can tell you that when the hospital ceased, it left a massive fissure in many a heart. For those with loved ones at Camarillo, the hospital offered security and peace of mind. It provided stability for their lives and offered a comradery between themselves that outsiders might not (and often did not) understand. For many of the patients there, Camarillo was homelike, routine, and dependable. To others, it was a place of struggle but also of hope and promise. For staff, it was a world where mothers and fathers might bring their sons and daughters to play on the grounds when they were little and apply for a job when they grew up. People met friends, teammates, and spouses there, and although many came to work only a summer, they ended up spending a lifetime. It was a unique place and time. I cannot help but wonder if we are truly better off now without Cam, given the current mental health issues that we face today and certainly in light of the horrible event that recently occurred in my own hometown. I have my doubts.

—Evelyn Taylor

It was during a rainy winter day in 1989, while working at my first teaching position within the private school system, when I first heard the name "Camarillo State Hospital." A coworker initiated a discussion about her sister being an RN at the "crazy hospital" located in Camarillo, and she went on to furnish all sorts of scary stories about working there. Being young, from Los Angeles, and fresh out of school, I had no idea where the city of Camarillo was located, let alone anything about a crazy hospital—*One Flew Over the Cuckoo's Nest* came to mind. I tried to put those frightening stories to the back of my mind, reassuring myself that my coworker was just being dramatic, and I went about my business. I married, and shortly after the birth of my daughter, the Northridge earthquake hit our area, causing us to relocate. We found ourselves moving northwest into a small town by the name of Camarillo.

It was not until 1998, while attending school to become a pharmacy technician, that it came to my attention that a university was opening up in my area. What I found to be most interesting was the location: the grounds of the former Camarillo State Hospital. It was as if a light came on, as I remembered what my coworker had told me so many years earlier. Being an avid photographer, what else would and could I do but put my young daughter and camera bag into the car and head toward the abandoned buildings that I had heard so much about?

I managed to squeeze time in between attending pharmacy technician school and my teaching job to photograph as many hospital architectural details as possible. From the long corridors, tiled surgical rooms, and intricate nurses' stations, to the pastels of the day and dorm rooms, I was intrigued. The fear of the unknown that once plagued my imagination was gone. Instead, I became fascinated. What was life like then? Photography had inspired me to explore building function and courtyard design, but the pictures just could not tell the complete story.

I continued to photograph there until the buildings were no longer accessible and the university opened. During that time, I amassed approximately 6,000 images of history. My daughter began college, and for one of her classes, she considered making a film about Camarillo. I offered to research the history of the buildings that I had come to know so well, and although my daughter ended up changing her focus, I embarked on the journey for information. Through this endeavor, I have come to realize that there was far more to the "crazy house" than many would acknowledge. Camarillo State Hospital was a myth that came to life for me and with this book, and I hope it will for you as well.

—Mary Holt

When I Rise Up

When I rise up above the earth,
And look down on the things that fetter me,
I beat my wings upon the air,
Or tranquil lie,
Surge after surge of potent strength
Like incense comes to me
When I rise up above the earth
And look down upon the things that fetter me.

—Georgia Douglas Johnson (1880–1966)

One

THE EARLY YEARS
1929–1936

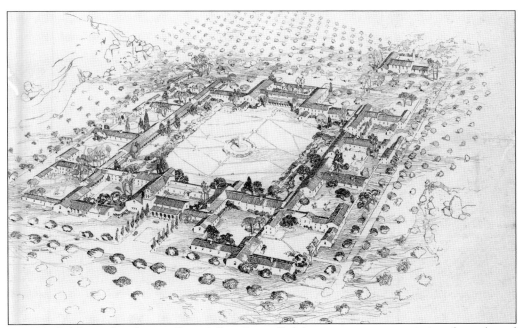

In 1929, California legislation allowed Gov. James Rolph to appoint a commission that selected and purchased the former Lewis Ranch for the future Camarillo State Hospital. This illustration is architect Howard Spencer Hazen's initial sketch of the first buildings of the hospital, which led state architect George McDougall to later proclaim, "The landscape architecture will transform the hospital into one of the most beautiful spots in California." (Courtesy CSUCI.)

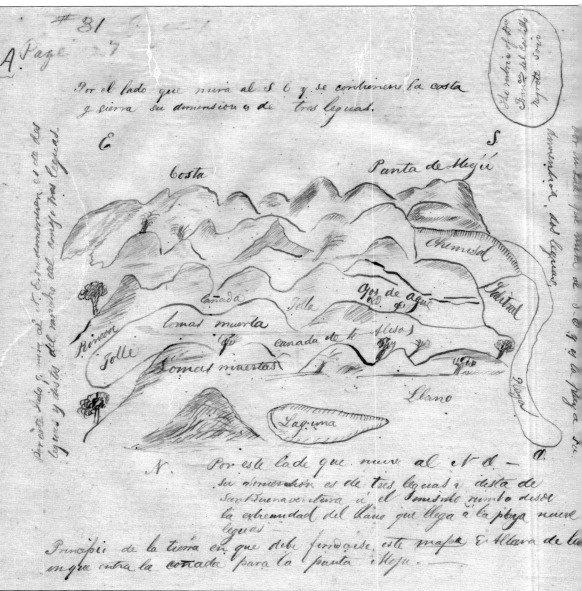

Camarillo State Hospital was built on Chumash land that once belonged to Ysabel Yorba, granted to her on May 6, 1846. Ysabel married Jose Joaquin Maitorena, a lieutenant in the Spanish army, and after his death, she petitioned Gov. Mariano Chico for a land grant. The land comprised the extreme southern part of Ventura County, bordered on Los Angeles County about 2 miles, on the coast about 8 miles, and extended into the interior about 10 miles. The governor originally excluded a lagoon and a plain, giving ownership to the local mission, which later offered those lands for purchase. Ysabel then applied for and was granted the additional land, which became over 30,593 acres, with approximately 925 heads of cattle and 70 horses. Ysabel sold her rancho for $28,000 in gold, with the remains of her estate left to her adopted daughters. Rancho Guadalasca, as seen here, was later parceled off and sold to various county residents, including Joseph Lewis in 1906. (Courtesy the Bancroft Library.)

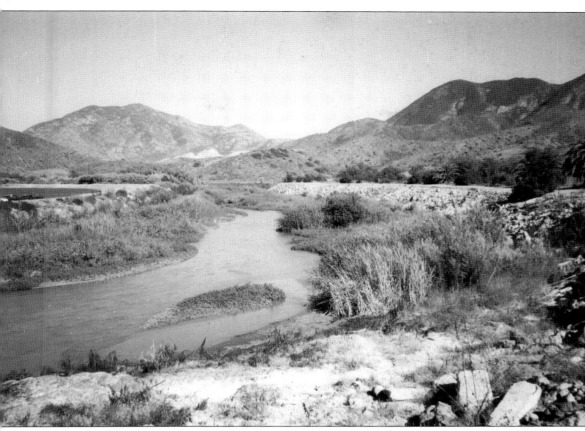

At the turn of the century, Joseph P. Lewis, now known for establishing lima beans and walnuts in Ventura County, entered into a business partnership with Adolfo Camarillo in 1901. Together, they actively farmed approximately 10,000 acres, which later became portions of Camarillo State Hospital. In 1906, when the partnership dissolved, Lewis bought approximately 8,000 acres on the Guadalasca site. With the Santa Monica Mountains in the background, this photograph captures perfectly the natural beauty of the area. (Courtesy CSUCI and Judy Lucas.)

In 1919, a lawsuit resulted in the dissemination of over 22,000 acres of Rancho Guadalasca, owned by William Broome, adjacent to Adolfo Camarillo's 8,000 acres. As the Rancho's frontage was 10 miles of Pacific Ocean, officials contemplated creating a coast highway from Santa Barbara to San Diego or opening a resort on the beach of Point Mugu. This c. 1950 map provides a bird's-eye view of the land. (Courtesy CSUCI.)

THIS INDENTURE, Made the 27th day of May, in the year of our Lord, one thousand nine hundred thirty-two, between PROPERTIES, INC., a corporation, party of the first part and STATE OF CALIFORNIA, party of the second part,

WITNESSETH, that for and in consideration of the sum of Ten and no/100 ($10.00) Dollars, in hand paid by the said party of the second part, the receipt whereof is hereby acknowledged, the said party of the first part does by these presents grant, bargain, sell, convey and confirm unto the said party of the second part, and to its assigns forever, all that certain lot or parcel of land described as follows, to-wit:

Part of the Rancho Guadalasca, in the County of Ventura, State of California, as granted by the United States of America to Ysabel Yorba, by Letters Patent dated September 1, 1873, recorded in the office of the County Recorder of said Ventura County in Book 1, Page 153, et seq., of Patents; particularly described as follows:

Beginning at a 6-inch iron pipe filled with concrete, 2½ feet below the surface of the ground, set at Corner No. 1 of the final survey of the Rancho Guadalasca and corner No. 19 of the final survey of the Rancho El Rio de Santa Clara o' La Colonia, at the extreme Southerly corner of Tract No. 2 of the Rancho Ex-Mission; thence from said point of beginning, along the boundary line between said Rancho Guadalasca and Tract No. 2 of Rancho Ex-Mission,

1st - North 42° 37' East 6809.82 feet to a 2-inch iron pipe; thence,

2nd - South 47° 23' East 40.00 feet to a 2-inch iron pipe set on the East line of a certain public road locally known as and called "Somis Road", described in the deed to Ventura County recorded in Book 114 page 40 of Deeds, said point being the point of beginning of that certain right of way for road purposes described in the deed to Ventura County recorded in Book 148, page 171 of Deeds; thence along the Southeasterly line of Somis Road, above referred to,

3rd - North 42° 37' East 4793.33 feet to a 2-inch iron pipe, which bears South 47° 23' East 40.00 feet from a point in the Northwesterly line of Rancho Guadalasca, which said point is South 42° 37' West 1659.67 feet distant from Corner No. 8 of the final survey of said Rancho Guadalasca and Corner No. 3 of the final survey of the Rancho Calleguas; thence,

4th - South 47° 23' East 2810.79 feet, parallel to and 30.00 feet distant from the Southwesterly line of the lands described in the deed to Lulu Lewis, recorded in Book 148, page 31 of Deeds, to a 2-inch iron pipe, from which the most Southerly corner of the lands described in the deed to Lulu Lewis, above referred to, bears North 40° 09' East 30.03 feet distant; thence,

5th - North 40° 09' East 750.96 feet, along the Southeasterly line of the lands described in the deed to Lulu Lewis above referred to, and the prolongation thereof, to a 2-inch iron pipe; thence,

After examining over 200 pieces of property, state officials met on April 29, 1932, to confirm the Lewis Ranch near the city of Camarillo, 66 miles northwest of Los Angeles, as the site of the newest California mental hospital. The purchase price for the 1,760-acre site was announced as $415,000, including the buildings, water systems, and crops. The 1929 legislature appropriated $1 million, and the 1931 legislature added an additional $455,600 for the purchase of the site and completion of the first unit. State architect George McDougall and Ventura architect Harold Burke rushed plans, as work was to initiate in a few months. Ground-breaking occurred under Gov. James Rolph on August 18, 1933, with over 2,500 persons from San Diego to Santa Barbara in attendance. Earlier that year, the hospital was forced to repurpose the Lewis Ranch farmhouse; the first 10 male patients having already arrived with three staff. Governor Rolph would later assert, "The hospital will stand as a monument to that human, kindly man who takes such an active interest in those less fortunate than ourselves." (Courtesy CSUCI.)

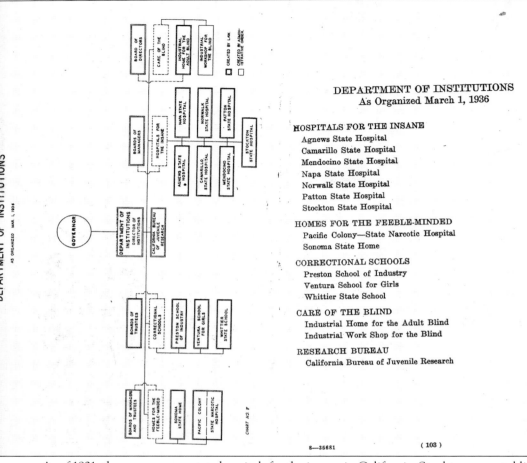

DEPARTMENT OF INSTITUTIONS
As Organized March 1, 1936

HOSPITALS FOR THE INSANE
Agnews State Hospital
Camarillo State Hospital
Mendocino State Hospital
Napa State Hospital
Norwalk State Hospital
Patton State Hospital
Stockton State Hospital

HOMES FOR THE FEEBLE-MINDED
Pacific Colony—State Narcotic Hospital
Sonoma State Home

CORRECTIONAL SCHOOLS
Preston School of Industry
Ventura School for Girls
Whittier State School

CARE OF THE BLIND
Industrial Home for the Adult Blind
Industrial Work Shop for the Blind

RESEARCH BUREAU
California Bureau of Juvenile Research

8—35681 (103)

As of 1921, there were seven state hospitals for the insane in California: Stockton was established in 1851, Napa in 1872, Agnews in 1885, Mendocino in 1889, Patton in 1889, Norwalk in 1913, and Camarillo in 1929. In the beginning, the government of each institution was described in the act creating it, but in 1897, a more uniform system of government was established by the Insanity Law. The Commission in Lunacy was created to ensure that all laws regarding the hospitals were properly and uniformly executed. In 1921, the hospitals were officially placed under the Department of Institutions. As of 1936, when Camarillo opened, there were 20,000 patients in the state hospital system. Patton State Hospital housed the largest population at 4,225. Camarillo was expected to house 7,500 patients and 1,500 staff at its fullest capacity. (Courtesy CSUCI.)

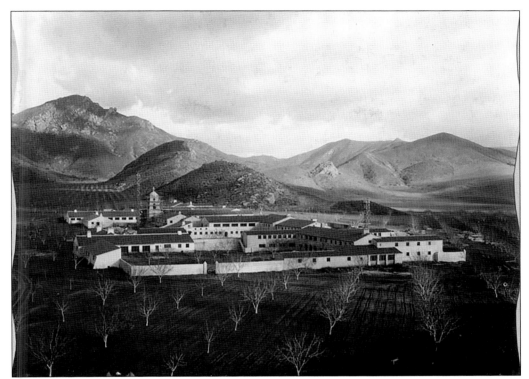

In 1933, plans were made to build the largest state hospital in the United States, within the 1,880 square miles of Ventura County, California, population approximately 55,000. The hospital settled near 50 miles of coastline and lakes, trails, and hot springs. It nestled among mountains and fertile valleys with walnuts, oranges, lima beans, and sugar beets, near adjoining hills of oil wells. Work began immediately on the first two units of the initial $7 million project. The population would grow from 107 in 1936 to over 1,100 in 1941, as demonstrated here with the men's unit, pictured c. 1935 above and c. 1940 below. It was expected that the total price of the hospital would exceed $10 million. (Both, courtesy CSA.)

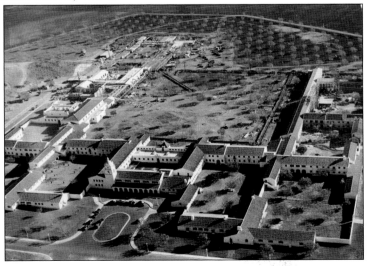

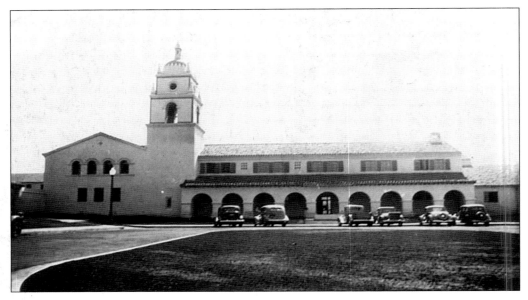

One of the original and most prominent structures of the hospital was the Bell Tower of the men's unit. Construction began in 1934 and was completed by the opening ceremony on October 12, 1936. The Bell Tower complex would serve many purposes during its existence, functioning as a hospital, an administrative unit, dormitory, and even providing cooking and eating facilities. The state had $1.8 million available for future construction, which provided for another 1,250-patient unit. It was anticipated that it would house 3,000 male patients before funding was exhausted. Decreased state revenues and impacted overcrowding at other state institutions made the construction of Camarillo imperative. The Bell Tower would later become an iconic feature—so much so that many people incorrectly associate it with the Eagles' "Hotel California." (Both, courtesy Carl Giesler.)

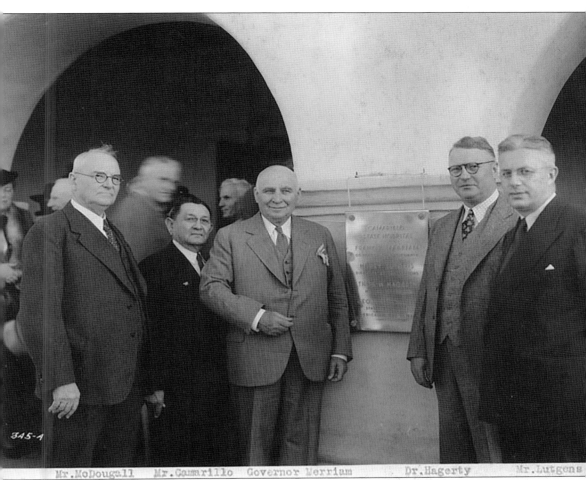

The opening ceremony of Camarillo took place on October 12, 1936. It was attended by, from left to right, George B. McDougall, state architect; Adolfo Camarillo (for whom the hospital was named), beloved pioneer; Frank F. Merriam, governor; Dr. Thomas W. Hagerty, newly elected medical superintendent; and Harry Lutgens, director of institutions. Dr. Hagerty delivered an address outlining the functions of the hospital, while Governor Merriam revealed the bronze dedication plaque prominently displayed at the Bell Tower foyer. He declared, "Camarillo State Hospital is destined to be the greatest of its kind in California." The hospital was built with the assistance of the Public Works Administration (PWA) funds, as part of the New Deal of 1933. Most of the New Deal spending came in two waves from 1933 to 1935 and again in 1938; it ceased in 1944. (Courtesy CSA.)

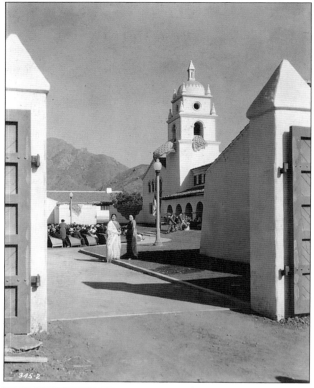

The opening ceremony of the "red-tiled city" took place in front of the Bell Tower, with over 1,000 people attending the festivities. The notable Camarillo family, Ventura County's first pioneers, as seen here, attended in traditional Spanish attire and joined in a formal welcoming of the institution to the community. A Spanish orchestra from Santa Barbara entertained, and Harriet H. Hegstad, music teacher at the Ventura School for Girls, sang *The Star Spangled Banner*. Dr. Hagerty commented, "I hope that the fame of this institution will not rest alone on the fine site and buildings, but also, on the work done here." (Both, courtesy CSA.)

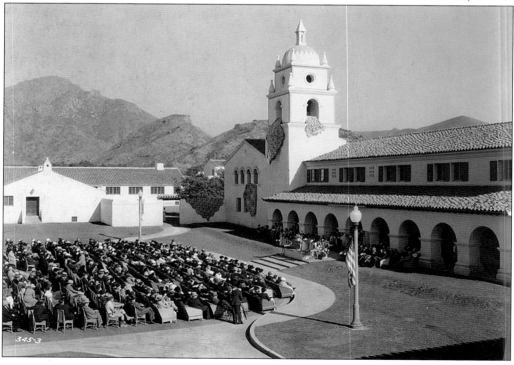

One of the first three buildings built, the Bell Tower building, completed in 1936, demonstrably reflected Howard Hazen's California adaptation of Mediterranean and Spanish styles, predominant in California from 1910 to 1940. Hazen was a senior architectural designer for the State of California's Division of Architecture. He appreciated the Spanish Colonial Revival movement and guided construction of the buildings in a style fusing Medieval Spanish Christian and Moorish architectural styles, believed to provide both therapeutic and restorative value. The Bell Tower's receiving area displays beautiful mission-era details of wrought-iron light fixtures, glazed polychromatic ceramic tile walls, and ornamental stucco and plaster. (Both, courtesy NARA.)

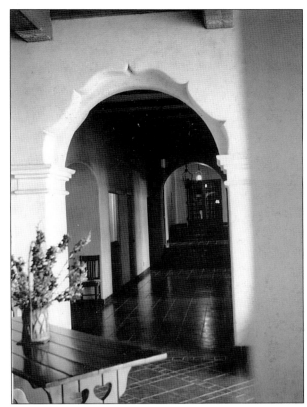

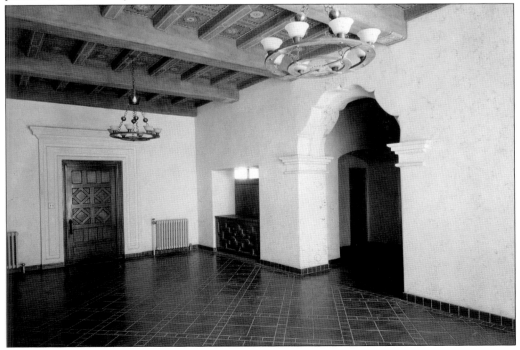

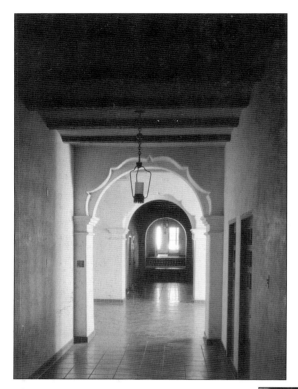

Examples of the horseshoe arch, also known as the Moorish arch and the keyhole arch, can be seen here in the adjoining hallway of the interior receiving area and the immediate portico of the Bell Tower building. The horseshoe arch is emblematic of Moorish construction and characteristic of the hospital design. Associated with pre-Islamic Syria, the horseshoe arch developed its distinctive form, first in Spain, as a symbol of sainthood and holiness, and then in North Africa, as a protector against the evil eye. The Visigoths used them as one of their main architectural features, which may stem from their capture of Rome in 410. (Both, courtesy NARA.)

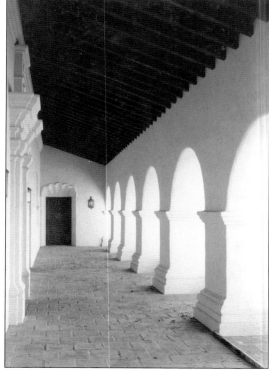

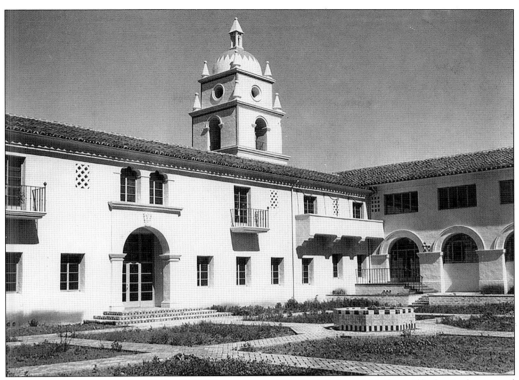

The interior courtyards of the Bell Tower were filled with beautifully grilled windows and balconies, ceramic tile fountains, terra cotta roofs, and serene gardens encouraging a place of rest and reflection. As illustrated in the bottom photo, Moorish gardens were centered around a water source, such as a well or fountain. Camarillo was built solely to relieve overcrowding; just a month after the opening ceremony, 250 patients from Patton State Hospital were transferred by train. Before year's end, 200 male patients arrived from Norwalk Hospital, joining the 100 men who were already housed at the Lewis Ranch. It was expected that every few days, new patients would arrive. (Both, courtesy NARA.)

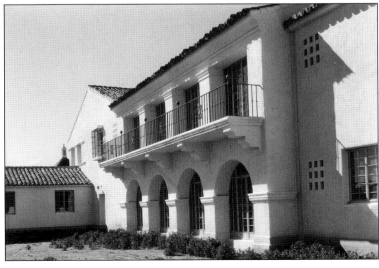

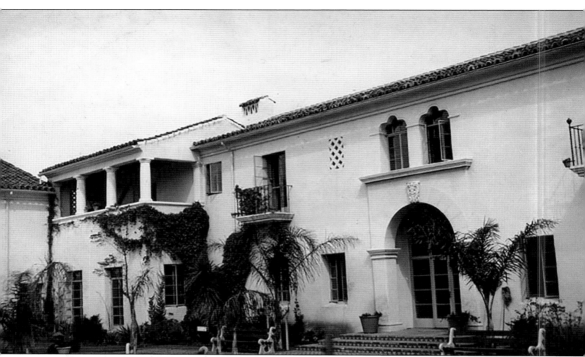

The courtyard at the back of the Bell Tower complex, as seen here in its Moorish grandeur, was inviting to both patients and staff as a welcomed model of buildings to come. The hospital would be erected in units; the first (Bell Tower) would comprise a men's ward and hospital structure, while the second would include a service building, matrons' shop, dining room, and boiler plant. Employing hundreds of men to complete them, the buildings consisted of two stories and a basement, with reinforced concrete walls, tile roofing, tiled and hardwood floors, and gas and steam-heating systems. Harry Lutgens, director of institutions, commented on the open-air building design: "California provides unusual climatic features [that] gives us a chance to let the patients exercise frequently." Funding for the construction was provided in part by the Public Works Administration, which allotted $184,000 in 1934. (Courtesy NARA.)

By May 1937, the patient dining (above) and service buildings (below) were completed, as seen here. New buildings anticipated included a female unit (patients of both sexes were housed together in one of the finished buildings), a research building, a medical unit, and quarters for aged and infirmed patients. The initial units included a series of low, red-roofed building with enclosed patios or courtyards. Offered were exercise facilities and various sports, including tennis, softball, and badminton. Women patients also enjoyed needlework and painting classes, while the men were trained in various crafts. Employing modern-day therapy, the hospital utilized habitation techniques such as hydrotherapy, spinal spray bath treatments, and immersion courses. (Both, courtesy CSA.)

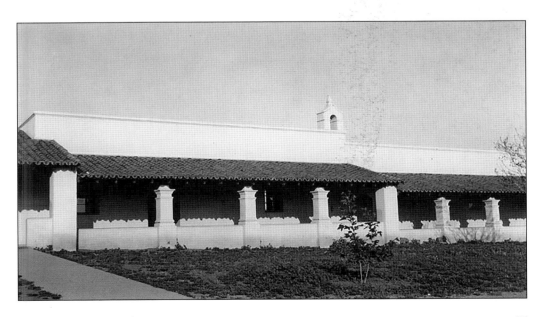

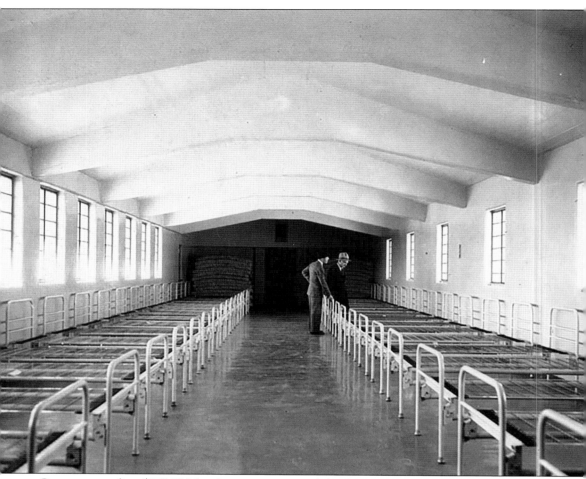

Contracts totaling $259,706 for the construction of the first two hospital buildings (Buildings 1 and 5 for 300 male patients) were awarded in June 1936. Louis Geisler, of Huntington Park, California, received a general contract confirmation on his bid of $214,995. Three more units were added to the list later in the year. Here, Geisler (in a black bolo hat) stands with a state official in the new patient wards. With overcrowding in state hospitals at over 35 percent, by January 1937, approximately 300 female patients arrived quickly to Camarillo from Patton and Norwalk hospitals, marking the first contingent of women arriving at the new hospital. This boosted the total number of patients to nearly 1,000. In September, 200 women and 20 men, patients of Patton State Hospital, were transported to new quarters recently completed. By April 1938, the male dormitories were accommodating 2,400 patients, as Camarillo began receiving additional patients from Santa Barbara and Kern Counties. (Courtesy Carl Giesler.)

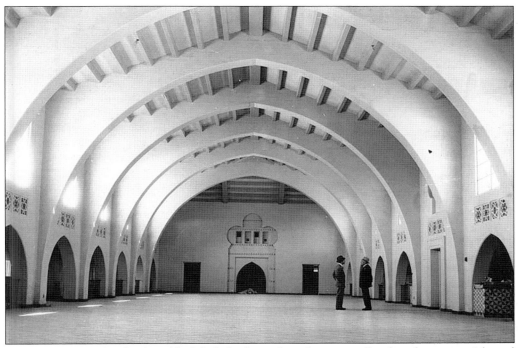

Contractor Louis Geisler (in a black bolo hat) stands with a state official in the patients' formal dining room in the men's unit (above), presumably discussing future plans for Camarillo. The patient dining hall on the men's unit was grand, alluring, and elaborate by design. The dining room provided for 400 patients a sitting and served as a multipurpose room. At the time of this photograph in late 1936, there were already 20,000 persons housed in state mental institutions, with accommodations for only 14,000. Three years later, the P.J. Walker Company of Los Angeles became the low bidder ($605,500) for general work of nine future buildings to serve female patients at the newest ward, being built directly across from the men's unit. (Above, courtesy Carl Geisler; below, courtesy CSA.)

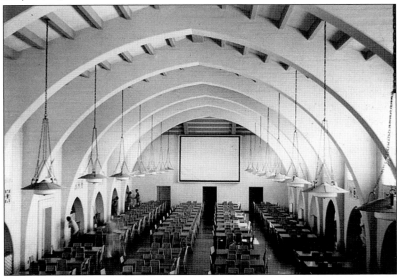

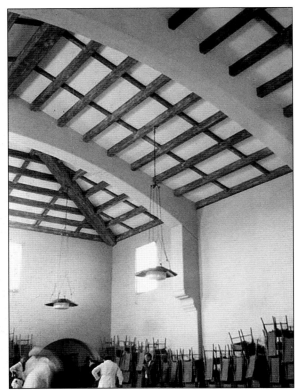

By 1937, there were approximately 120 employed at the hospital. The staff dining room, depicted here with its beautifully exposed geometrically organized wooden ceilings and ornate chandeliers, offered a sense of delicate beauty and peace. At that time, future employees also faced a lack of housing at the hospital. In fact, the City of Oxnard Chamber of Commerce met with state officials to discuss additional housing for 75 families and 20 doctors, at a rental price of $20 per month. Construction of houses was planned at the cost of $12,000 per month. Facing a shortage, doctors looked to the City of Ventura for residence. (Both, courtesy CSA.)

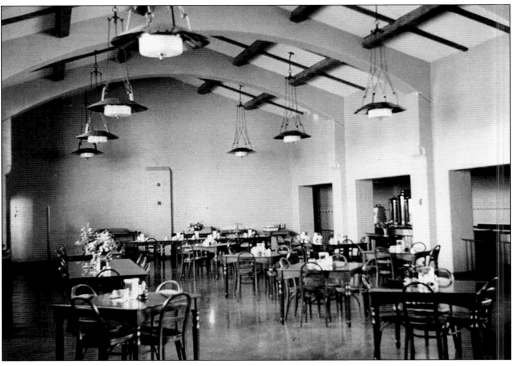

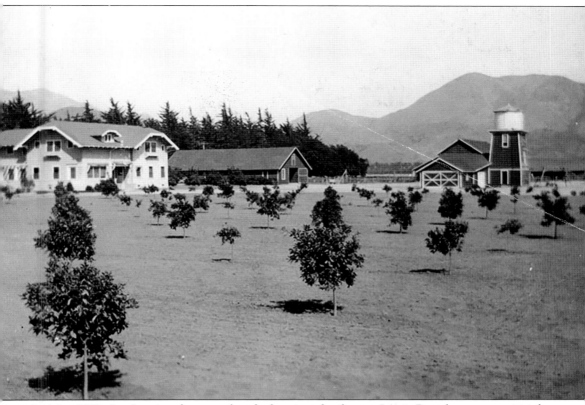

In May 1932, Joe Lewis, who was already farming the former Lewis Ranch, was appointed superintendent of the 1,700-acre ranch now owned by the state. It was the only state ownership holding that was self-supporting. In its earliest year, 1929, the lima bean crop alone brought in $100,000. Ventura, at the time, was known as the greatest lima bean producer in the world. Hospital crops were of a wide variety, including, but not limited to, squash, tomatoes, and watermelon. The orchard consisted of approximately 80 acres of apricot, grape, nectarine, peach, walnut, and youngberry trees. Farm acreage increased in the next decade to approximately 300 acres of alfalfa, 227 acres of vegetables, and 178 of grain crops. In 1937, the University of California began using the Camarillo hospital farm for experimental bean plots. (Courtesy CSA.)

Lima beans were not only the money-making crop of Camarillo; they were the staple of Ventura County, and the Lewis Ranch was well known for its contribution to the popularity of this little bean. While stories vary as to the origin and first planter of the lima bean, the story relating to Henry Lewis (Joseph Lewis's father) is that he obtained the beans from a sailor from Lima, Peru, around 1868, and from there, he elevated them to the highest grade of lima beans, known as the "Lewis bean." Joseph F. Lewis was born on his father's plantation in the city of Carpinteria, worked on his father's ranch for a time, and then rented 260 acres of the Camarillo Ranch to plant lima beans in that section of Ventura County. He formed a farming partnership with Adolfo Camarillo in 1901. When that dissolved in 1906, Lewis bought 8,200 acres of Rancho Guadalasca to farm 2,000 acres in beans, 2,000 acres in beets, hay, and grain and utilized the rest as grazing land for his stock. (Courtesy CSA.)

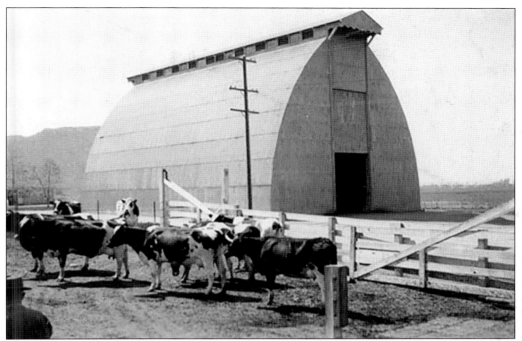

In 1953, the dairy consisted of 523 Holstein cows. By 1956, the hospital owned 550 heads of stock and produced 35,000 gallons of milk monthly. The herd, as seen above, had 40 acres of permanent pasture and 300 acres of alfalfa for feed. All replacement stock was bred and raised at the farm, as part of the hospital's rehabilitation program. Milking and farming operations were supervised by employees who were assisted by the patients. The dairy was located about two miles east of the hospital's farm, with the headquarters centered on Lewis Road. The milk barn and hay shed, calf pens, chickens, corrals, and hogs were located on a 20-acre site. The hospital ranch was one of the first in the area to use the pesticide DDT. (Both, courtesy CSA.)

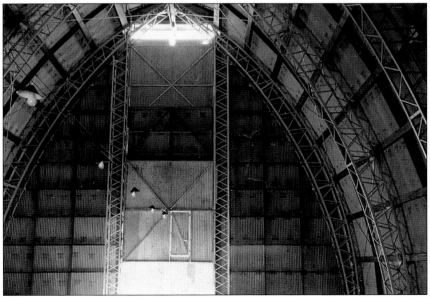

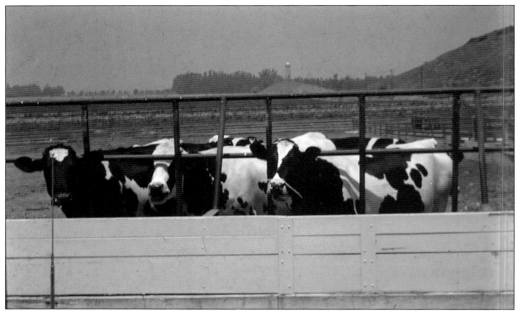

Patients not only worked the dairy but also participated in festivities that included the dairy and ranch. In 1941, the hospital held a rodeo for the patients, with the county's finest horses taking part in the western show. Carmen Camarillo rode her horse Diamante, while Frank Camarillo directed the reining (horse) contest. Patients also enjoyed the cow milking competition. The patient and employee band furnished music. (Courtesy Sherry Warrick.)

Raising cattle would prove to be a lucrative venture for the hospital. Cattle value in 1930 was $65.80, while 1940 saw a decline to $41.60, prices rose in 1950 to $123. Holstein cows were named so because of their native German provenance. Not all Holsteins are black and white; some are red and white. Full-grown, they can weigh up to 1,500 pounds, producing milk with a large butter fat content. (Courtesy CSA.)

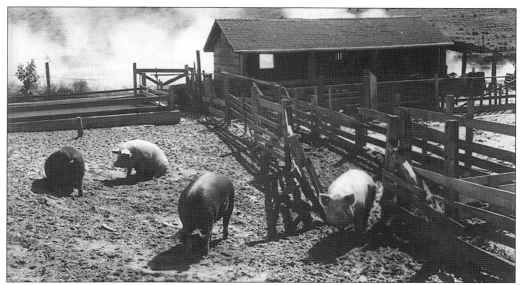

Raising hogs as seen here at the Lewis Ranch promoted early community involvement. In 1930, boys and girls involved in the 4-H Club met at the Lewis Ranch to make selections of feeder pigs. Lewis himself offered prizes of three pigs to give to winners to raise, hoping to continue the children's interest in agriculture. In 1953, hog operations increased the feeder pigs to 497. (Courtesy CSA.)

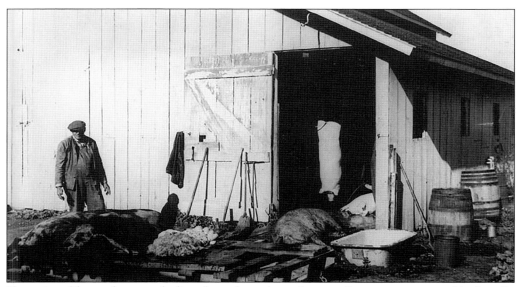

Hog prices, like cattle, saw a decline throughout the early years. Prices were measured by "cwt," a unit of measurement equal to 100 pounds. An average hog could weigh up to 300 pounds, producing approximately 220 pounds of lean meat. In 1920, one would be sold on average for $14.80; in 1930, $9.90; in 1940, $6.00. The year 1950 saw the greatest leap in price to $20.30. (Courtesy CSA.)

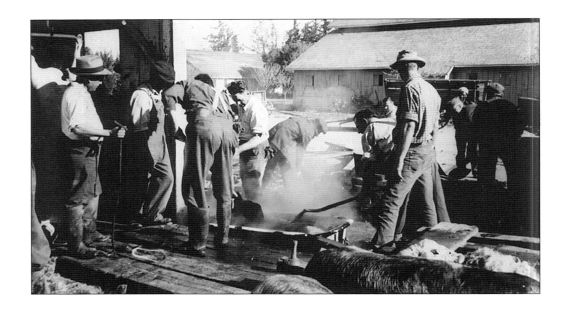

By 1956, the hospital's ranch housed 125 patients. Approximately 150 patients worked the ranch eight hours per day, with the extra help coming from the main hospital when workers were needed for the harvest. Patient duties on the ranch included spreading fertilizer, plowing, and loading the wagons with farm produce. As Superintendent Nash stated, "We have one old fellow here who wouldn't be happy, unless he was driving the team [of horses]." Machinery was utilized for the majority of farm chores and was not patient-operated. A self-contained unit, the hospital also had its own slaughterhouse and icehouse. Warren Underwood, a retired ranch manager, witnessed the transition of many ranch operations from manpower to machinery. He noted that working at the ranch seemed beneficial to patients and that they enjoyed it. (Both, courtesy CSA.)

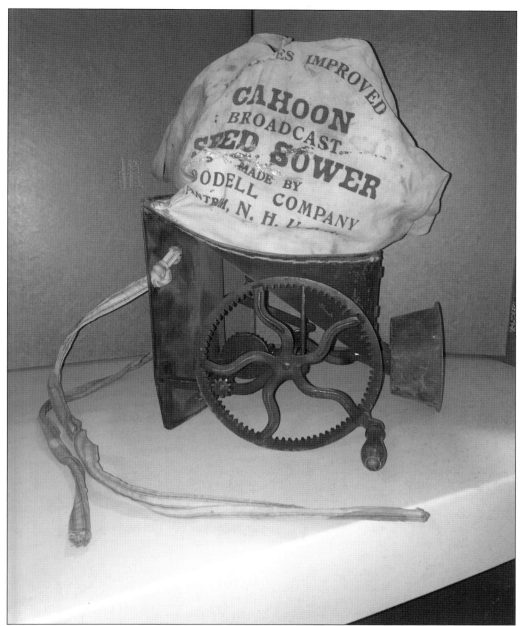

This early Calhoon Broadcast Seed Sower was utilized by ranch hands to scatter seeds of barley, grass, oats, rye, and wheat during the hospital's early years. The most important component of cultivating and maintaining the integrity of the agriculture of the ranch, however, was the quality of its water. In fact, the quality of the water on the Lewis Ranch underwent investigation in 1932, when it was first purchased. Finance director for the state Rolland Vandegrift testified as to the quality and quantity of water on the property. With the opportunity given to other ranchers and farmers to provide their opinions, the majority contended that the water on the land was "perfectly all right" for domestic and agricultural use and could be used for drinking with an added treatment, similar to other state instructions. (Courtesy CSUCI.)

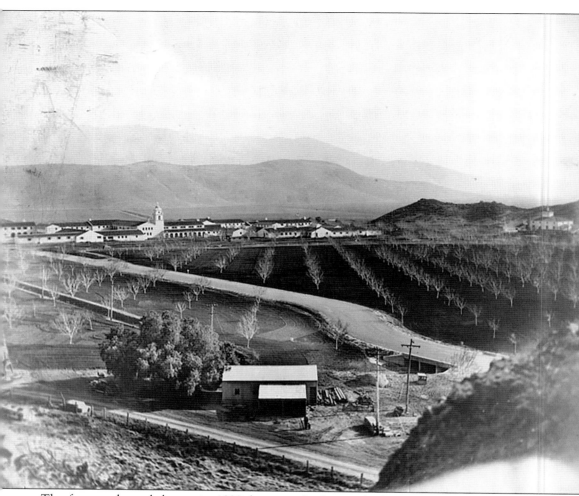

The farm and ranch began in 1929, keeping the hospital self-sufficient and independent. Nevertheless, as early as 1962, operations were in danger of closing. At the time, Camarillo had a herd of 500 cattle, of which 250 were milk-producing, and it was demonstrably economical for the hospital to produce its own milk. But Bruce Macy, business administrator, acknowledged that the time would come when the state hospitals would no longer perform farming operations. By January 1969, it was official that the farm would close in June. Dr. Louis Nash, superintendent and medical director, commented, "This is the last farm operation we have and I'm in favor of its elimination." Nash asserted that the hospital is now "out of the laundry business" and "should no longer be involved in providing such services, where they can be done equally well or better and more economical." He did not subscribe that a hospital should be self-supporting and largely dependent upon patient labor. "There is much more for the patients to do while they are with us, than to work to support the facilities." (Courtesy CSUCI.)

Two

COMING INTO ITS OWN
1937–1959

The iconic "A" all-key opened and closed all hospital doors for both the men's ("South Quad") and women's ("North Quad") units. It became an instant symbol of power and jurisdiction. During the early years, doors locked automatically when shut and the locks on the doors were different on each side, requiring at least two separate keys to enter and leave a room. (Courtesy Suzan Barosso.)

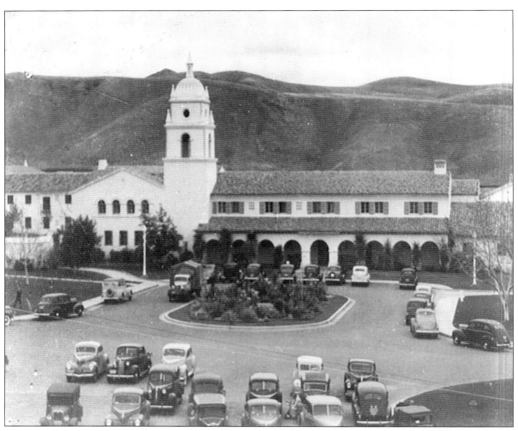

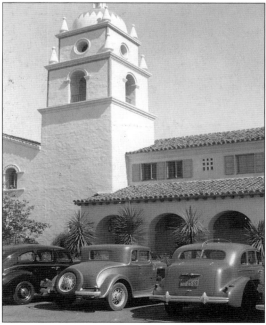

These c. 1937 views of the Bell Tower give an indication of the physical growth of Camarillo in just a year or so. The institution increased from 100 patients to approximately 2,500, before the first year's end and outside communities took notice. The Oxnard and Camarillo newspapers began carrying "Camarillo State Hospital" news as regular columns. The Oxnard Chamber of Commerce hosted a community dance for hospital employees. With gratitude, Dr. Thomas Hagerty stated, "[We] appreciate so very much the manner in which residents of the surrounding community have cooperated in putting on programs. Such an attitude made us feel so welcome from the very start, in what have seemed a new and strange territory for us to invade. We value highly the friends which we have made in our first year." (Both, courtesy CSA.)

In December 1941, Patton State Hospital transferred 100 men and 100 women to Camarillo. Overall, the overcrowded Patton sent 400 women and 200 men to Camarillo, since the previous October. As seen here, men lounging in the Bell Tower courtyards enjoyed peace, tranquility, and relief from the overcrowding of other state hospitals. Other state institutions employed various means to lessen the unfavorable conditions of inmates and patients. Patton deported patients to other institutions throughout the United States, while Los Angeles city police began transporting habitually intoxicated men and women to Camarillo's psychopathic ward. (Both, courtesy CSUCI.)

In late 1939, Camarillo became the center for treatment of early dementia praecox (an early diagnosis of a form of dementia) thanks to Dr. Jacob Frostig, a noted advocate of insulin shock therapy. Insulin therapy put the patient into a coma-like state, during which the brain tissues and cells "rested," providing time for recuperation. Dr. Frostig joined the staff in performing 29 initial treatments. Twenty-three patients were discharged as cured, five showed improvement, and one failed to benefit. Of the 21,884 patients in California mental hospitals a year earlier, 53 percent were schizophrenic, and 10 percent were manic-depressive. Both groups seemed to be helped by insulin. Administrators estimated that the average cost to maintain a patient for 10 years was $2,498; however, the cost of insulin therapy for one patient was just $145.30. One hundred eleven patients had already been released in just two years. (Courtesy CSUCI.)

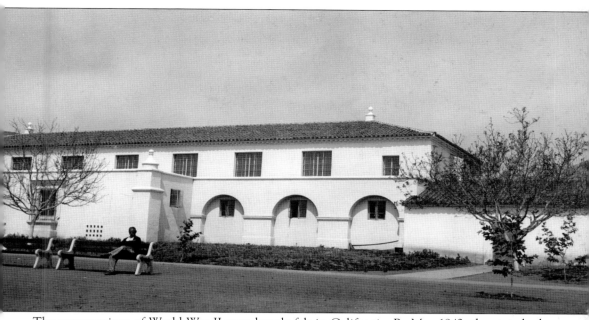

The repercussions of World War II were keenly felt in California. By May 1942, the state had put a plan in place that, in the event that Southern California cities were bombed or invaded, it would repurpose its mental hospitals as emergency treatments centers. Camarillo was one of seven officially designated as "Emergency Base Hospitals," with the ability to take 500 civilian casualties if need be. Moreover, when battle-weary veterans returned home, the state hospitals took on the responsibility of treating soldiers and sailors, along with civilians. In January 1946, the normal wartime caseload increased to 512 persons who submitted themselves to the Los Angeles Psychopathic Court, for help. One-third were categorized as alcoholics, while other cases consisted of schizophrenia, dementia, paranoia, and drug addiction. A building shortage at all of the state hospitals caused officials concern with this influx. By this time, Camarillo was 10 percent over capacity. (Courtesy CSUCI.)

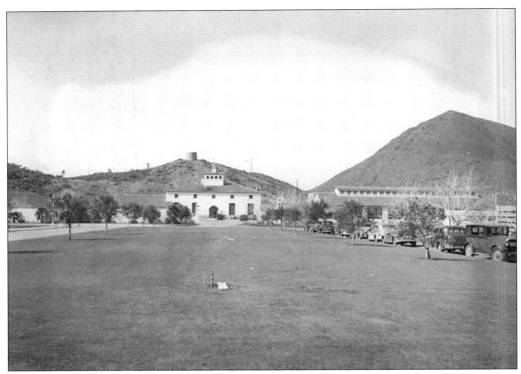

Construction continued on other portions of the hospital in 1936. Three buildings, attendants' quarters (apartments), sewage disposal plant, powerhouse (above), and laundry cost $241,000 to complete. At this time, the laundry (near the powerhouse) was ready for roofing, and the building of Units 6 and 7 was about to begin. The powerhouse heated and cooled the entire hospital by steam. In fact, the exhaust stack (left) behind the powerhouse (looks like a well) is featured in the cult classic *The Ring*. In December 1940, the director of institutions' budget for all state institutions in the next biennium totaled approximately $42 million. This included $6 million to take care of an increase in population at the state mental hospitals. At the time, a vast building program was underway at Camarillo, including additional women's units, physicians' cottages, and other supporting structures. (Above, courtesy CSA; left, Mary E. Holt.)

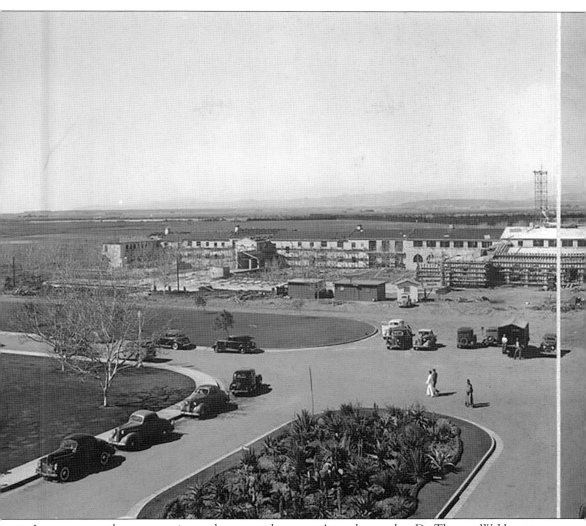

In response to the construction underway on the women's north complex, Dr. Thomas W. Hagerty, superintendent and medical director, stated, "When the new female unit is finished and filled . . . there will be 5,000 patients housed at the institution, making it the largest mental institution in the state." This stage of the building (February 1940) was anticipated to cost between $2.5 million and $3 million with medical staff expecting to double. Included in the funding were the attendants' quarters, residences of the staff, and the laundry building addition. When completed, the female unit would cover an area one-quarter mile square and would include courtyards, roads, sidewalks, and patios. By April of the next year, three wards would officially open for 300 women, with bids for five more units of the female wing being taken and plans for additional five wards in the works. (Courtesy CSA.)

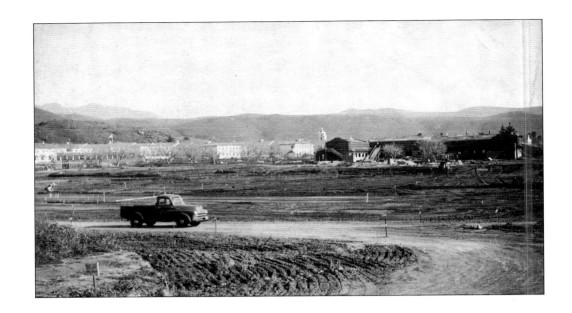

These photographs of the women's area (rear view) in 1941 show continued construction on the receiving ward (located directly across from the Bell Tower), insulin ward, occupational therapy room, drug laboratory, and schoolrooms. Eventually, the women and men would be separated into what would be routinely called the North Quad (women) and the South Quad (men). Nine initial units (buildings) of the North Quad would later include a new kitchen and dining room. Within the 9 units, were 11 wards containing 100 beds. When completed, it was expected that the new hospital wing would house 2,400 patients. At the time, patient enrollment was 2,600 at the South Quad. Funding was dependent on legislative appropriations. (Both, courtesy CSA.)

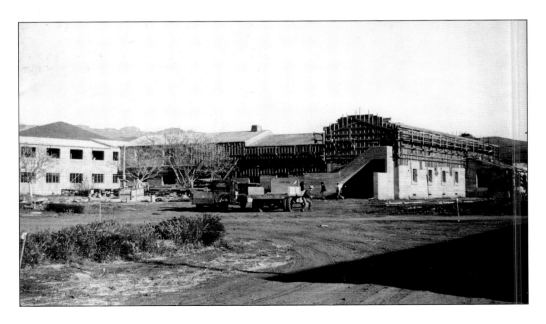

This is the women's administration building around 1940. By 1949, the women's complex was officially completed. Although the hospital might have appeared as a fortress, escapes from patients did occur. In 1940, the residents of the Hidden Valley area signed a petition demanding that the hospital be fenced, as several encounters continued to occur between neighboring community members and Camarillo Hospital patients. "Thursday night," claimed a rancher, "One of the escapees wandered on my ranch and threatened to kill me. He had stuck feathers in his hair and came at me with a club." Sheriff's office documentation indicated that 70 inmates had escaped from the hospital in 10 months. Dr. Thomas Hagerty, director, indicated that lack of sufficient personnel was partly to blame, as the hospital had no outside guards on the premises. (Both, courtesy CSA.)

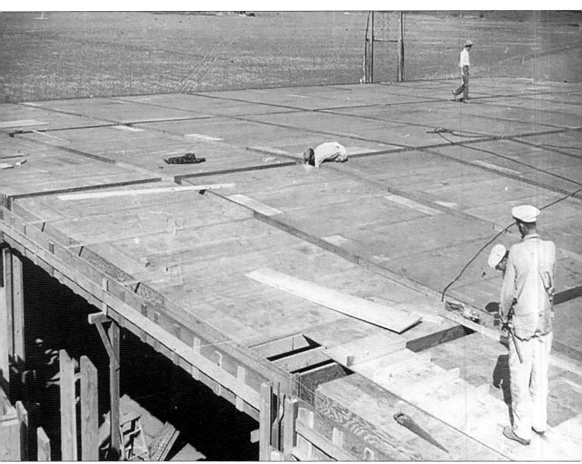

In 1943, the California Department of Institutions became the Department of Mental Hygiene, the predecessor to the Department of Mental Health. At that time, Camarillo faced a notable shortage of workers due to World War II. The hospital planned on opening new units if additional employees could be located. Such open positions included assistant bakers, attendants, cooks, electricians, firemen, kitchen helpers, laundrymen, machinists, masons, meat cutters, nurses, painters, physicians, seamstresses, social services workers, stenographers, and telephone operators. As new wards opened, male and female patients were separated; 1,400 female patients were moved into completely different sections of the north side. Here, workers stand on top of a future hospital bakery, which had the capability of producing 5,000 loaves of bread daily. Each month, the bakery utilized 7,000 pounds of flour, 3,000 eggs, 6,000 pounds of sugar, and 200 pounds of butter. (Courtesy CSA.)

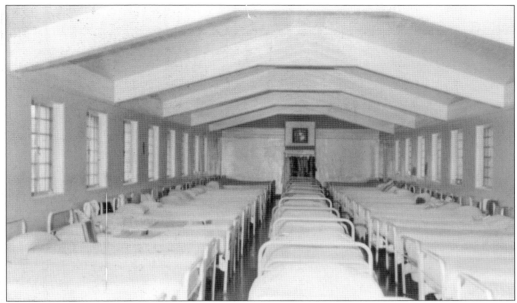

In July 1943, the hospital housed 3,843 patients. It had been one of two state hospitals (the other was Sacramento) to routinely employ insulin shock treatment to a high degree of success. An excessive shortage of physicians and nurses, presumably due to wartime demands, led to the discontinuation of insulin therapy, even with assistance with personnel from a University of California training hospital. In its place, electric shock treatment, using fewer employees, was begun two years prior. Electric shock treatment, now known as electroconvulsive therapy or "Edison medicine," sends a high-frequency electric charge through the brain, causing temporary unconsciousness. Patients received this treatment three times per week, and in almost all cases, improvement was shown. These photographs show the women's initial housing and courtyard areas. (Both, courtesy CSUCI.)

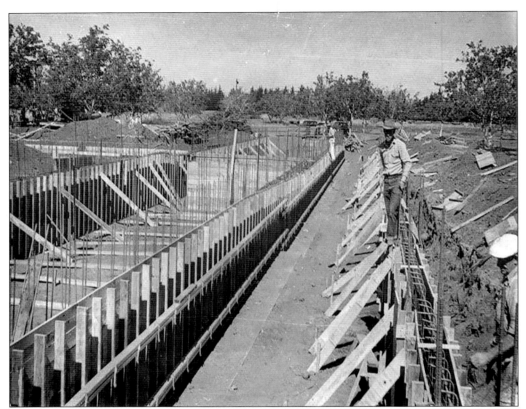

In July 1941, approximately 200 patients from Patton and 100 from Norwalk arrived at Camarillo, boosting the population to 3,520, making it the third largest in California. Building continued on the North Quad, as seen here with the dining room. Besides the women's unit, construction crews were kept busy on the commissary and the maintenance department (located next to the powerhouse), which would later house the electrical shop, firehouse, repair shops, and woodshop. All were utilized by hospital employees and patients. The increasing population also taxed recreational facilities at the hospital. Camarillo sponsored a public dance in a new unit in December, with the admission price of 40¢ per person, funding the purchase of pianos and other recreational equipment. The patient orchestra provided the music. (Both, courtesy CSA.)

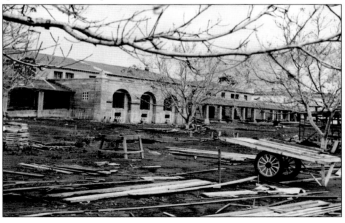

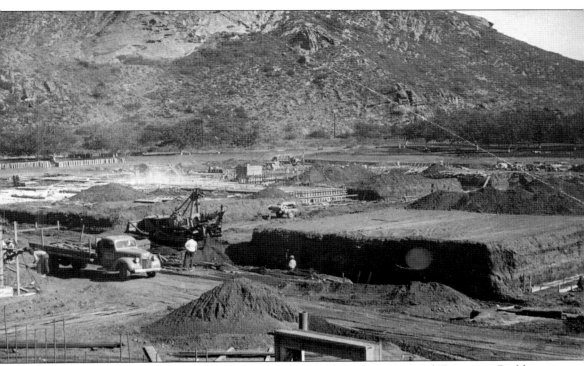

In October 1949, workers began laying the foundation of the Receiving and Treatment Building (where new patients were diagnosed and treated), seen here from a southeast view. At this time, Camarillo was already overcrowded. An excess population of 492 patients (overcrowding of more than 12 percent) necessitated filling dormitory aisles with additional beds. Some wards were so full that beds partly blocked doorways. Attendants converted a dining room originally meant to seat 24 to accommodate 119. The interruption of the building process during World War II made it necessary to convert the few existing dormitories into housing for the many. Patients were segregated according to the degree of their mental illness. One group of 28 women resided in unlocked quarters with an elected patient-housemother in charge. Their doors were locked to keep intruders out—not patients in. A juvenile program was also in place now, with many of the patients referred to it by juvenile court judges. The cost of caring for each patient was $50. (Courtesy CSA.)

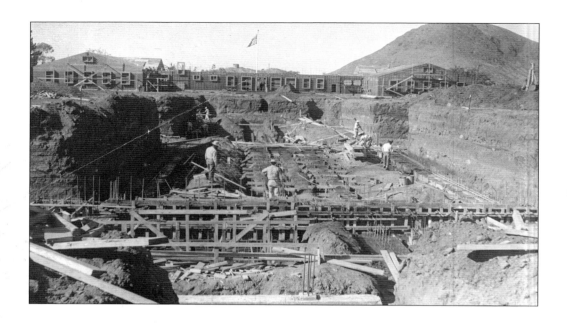

These construction photographs of Camarillo's administration building to the northwest and the Receiving and Treatment Building ("RT Building") show progression, beginning in October 1949 (above) to March 1950 (below). This bird's-eye view also indicates that the North Quad (in the background) was completed by early 1950, but that was not soon enough. In January 1949, there were 5,085 patients at an institution built for 3,010. Patients slept on mattresses on the floor. "Everything is done to make them as comfortable possible," Dr. Hagerty stated. Many of the wards, meant to provide 60 cubic feet of space for each patient, provided less than 20 cubic feet. An average of 250 to 300 new patients were admitted monthly, and most of them were elderly. (Both, courtesy CSA.)

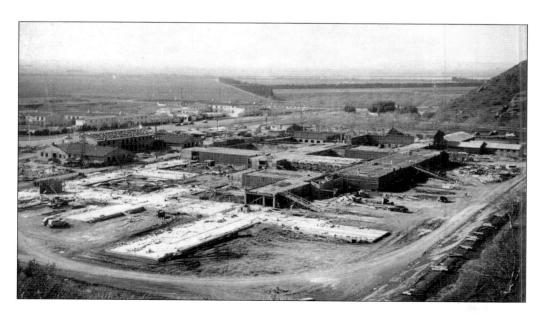

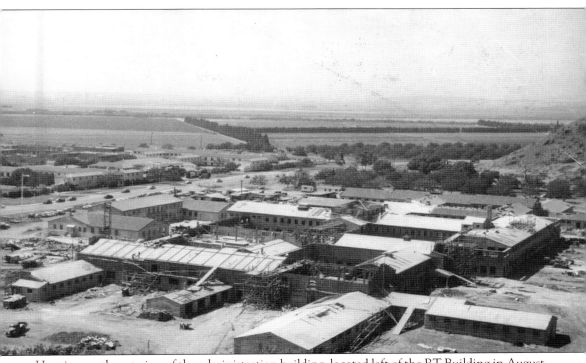

Here is a southwest view of the administration building, located left of the RT Building in August 1950. The RT Building would allow Camarillo to expand its therapy program, devote additional time to electric shock treatments, and provide enhanced facilities for lobotomy operations. Planned were four hydrotherapy units, where patients would receive warm water therapy and corresponding pack rooms, where they would be wrapped in cold, natural, and heated sheets to produce a sedative effect. The area would operate as a general hospital, with plans calling for one unit to accommodate 400 patients "acutely or chronically disturbed," another to accommodate 400 aged or infirmed, and a future 150-patient juvenile unit for behavior and emotional problems. The juvenile area was uniquely designed, consisting of a number of small cottages for housing 10 to 15 patients each, along with separate classrooms and occupational facilities. (Courtesy CSA.)

Feb, 16 - 1952

Adolfo Camarillo - accept with pleasure to be a guest at the Hospital Luncheon Feb: 20 - 12=30 P. m. Honoring Governor Earl Warren)

In May 1951, Camarillo featured mental health week, as part of the state hospital system's observance of the event. Tours enabled visitors to observe the operations of the institution. On February 20, 1952, Governor Warren dedicated the $3,500,000 Spanish red-tiled receiving and treatment ward with more than 500 people (including Adolfo Camarillo) attending the ceremony. He proclaimed that the building was not only new in construction but also new in spirit. The center would provide curative, rather than custodial facilities; it would be the very heart of a modern institution. The hospital contained $350,000 of the most modern dental, physiotherapy, surgical, and x-ray equipment. A month later, 50 new patients moved in, joining those who came from the overcrowded wards, moving up the capacity to 716. The surgical facilities began as well, with the pharmacy already in operation. The following week, the woman's occupational therapy section was set to open. (Both, courtesy CSUCI.)

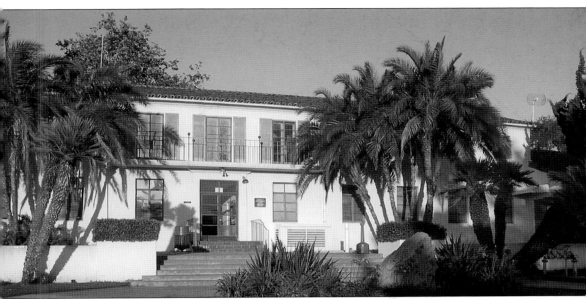

The new administration building, strikingly handsome with its blue plantation shutters and matching blue and white tile stairs, was nearly completed by 1952, as was the RT Building and bakery. The 800-bed receiving hospital was expected to be a "dream house," a sprawling two-story building that was earthquake proof and designed for the modern concepts of treatment. It would house patients requiring only a short hospitalization time of 30, 60, or 90 days. The suites were homey in size and decor. Areas were decorated in pastel shades, furnished with colorful chairs and tables, draperies in lively shades, and bathrooms and kitchens featuring colored tile. "We are getting away from white walls and beds," explained Mary Sylvia, superintendent of nursing services. In the women's section, strawberry pink and yellow were predominate, and in the men's area, it was green and gray. (Courtesy CSUCI.)

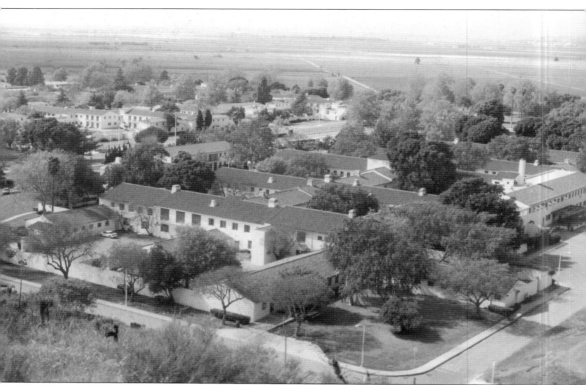

On an average day, there were 10 new admissions to Camarillo. As we can see from this southwest view of the hospital building (foreground), gone were the padded walls and iron doors. Windows carried screens resistant to heavy pressure, while doors were natural slabs. The central wing housed the treatment and surgical suites. There were various operating rooms, one with a galleria for student doctors, as well as dental and optical offices, a pharmacy, and insulated rooms for special therapy. At the rear was the commissary and kitchen, which supplied the dining rooms. Six of the wards were designated for the aged, complete with rocking chairs. Day rooms with patios and radios provided entertainment. Television was utilized as therapy for the patients, who were extremely avid viewers, preferring Western-themed shows. The occupational therapy center allotted space for weaving, painting, ceramics, and lapidary work. Along with the commissary was another new structure, the patient-operated "Canteen" (later the Hub), located in the North Quad, a place to go for an afternoon soda or hamburger. (Courtesy CSUCI.)

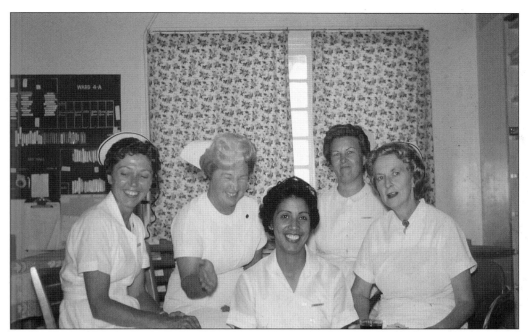

By March 1953, student nurses from three counties received part of their training at Camarillo. The nurses' program gave students classroom and clinical work, along with practical experience. The nurses went through a 12-week course at the hospital, where the average class numbered 25 students, and every 12 weeks, a new class entered the program. The students worked from 6:30 a.m. until noon and then attended classes until 3:00 p.m., five days per week, living in the dormitories on the hospital grounds. They wore their uniforms during the hospital time (similar to the nurse and attendant uniforms seen here c. 1951) and then changed into street clothes to work in the children's section. There were over 1,000 nurses on staff, with 450 volunteers. Members of the staff also conducted tours through the hospital and acted as hosts to events held there. (Above, courtesy Sherry Warrick; right, courtesy Howard "Buster" Smith.)

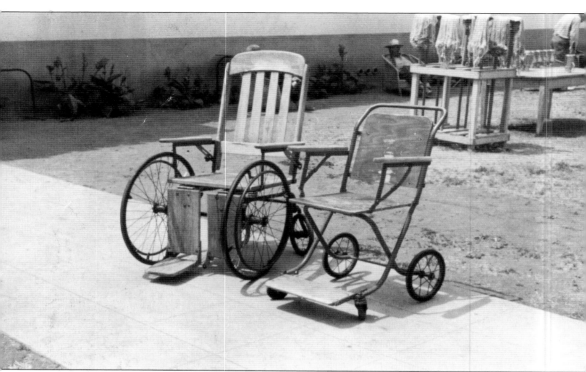

In 1949, approximately 800 patients watched the movie *The Snake Pit*, filmed in part at Camarillo (dining hall), which also became associated with the hospital in the public's mind. The patients, answering a questionnaire circulated by Dr. Thomas Hagerty, responded as follows: 323 replied that the movie was accurate, while 74 said it was not; 202 thought the doctors were true to life, and 89 disagreed; 275 thought the nurses were true to life, but 101 said no; and 346 said the patients depicted on the screen were true portrayals, and 40 said they were not. Asked if the general public should see the picture, 353 said yes, and 38 said no. Comments included, "I am a post-shock patient and find the shock scenes fill me with the same old dread," "the nurses and attendants here at Camarillo are not anything like the ones in the picture," "it's an excellent portrayal of this hospital," "enjoyed the picture, particularly, the cracks about the food at meals," and "it was Hollywood make-believe." (Courtesy CSUCI.)

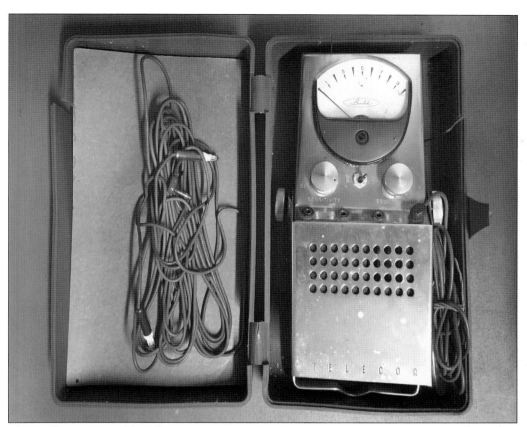

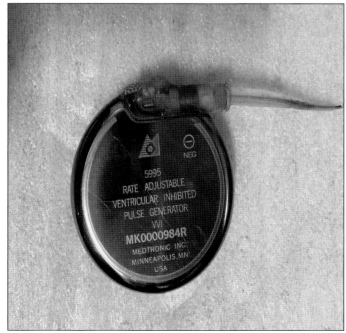

The cardiac monitor (above) was used from the 1950s to the 1960s. It dictated and registered cardiac arrest and arrhythmia. Hypodermic electrodes transmitted a signal of the heartbeat that was visually displayed on a gauge and a transducer, which was strapped to the patient's fingertip. It gave an audio signal of the pressure of the pulse. A heart pacemaker (right) is placed in the chest or abdomen to help control abnormal heart rhythms. The device uses electrical pulses to prompt the heart to beat at a normal rate. An average lifespan of this pacemaker was one to nine years. (Both, courtesy CSUCI.)

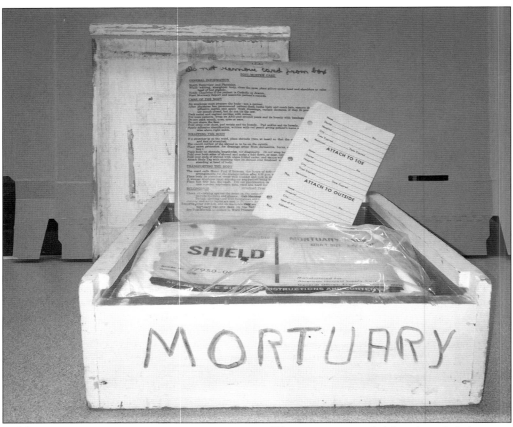

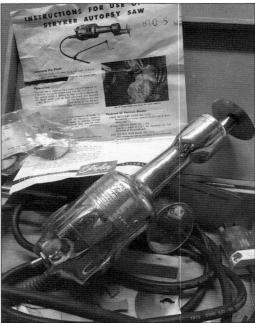

This mortuary pack (above) guided the care and preparation of the body, including the autopsy, before it was transferred to the local cemetery. This autopsy saw (below) was used for the dissection and removal of bone specimens. According to the Department of Mental Hygiene's 1953 Mental Disorders in the State Hospitals report, general maladies of patients consisted of alcoholism, drug addiction, cerebral arteriosclerosis, epilepsy, manic depression, paranoid conditions, psychopathic personality, sexual psychopathy, and schizophrenia. During that year, 16,852 persons were admitted to the 12 state hospitals, with the average over 1,400 patients per month. During an average day, there were about 35,000 patients in the hospitals, 7,000 on brief visits, 9,000 on extended leave, and 1,800 at the out-patient clinics. Camarillo's population size was well beyond average; in fact, it increased from 6,748 in 1953 to over 7,000 in 1957. (Both, courtesy CSUCI.)

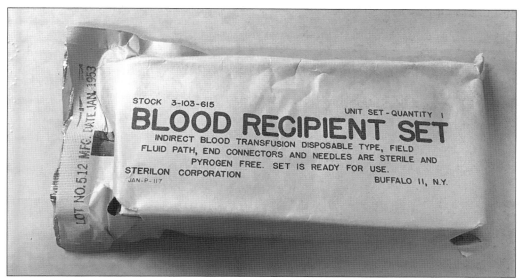

The 1953 blood recipient kit pictured above was used for transfusions, and the day waiting room pictured below accommodated patients as they waited for evaluations and treatments. By October 1947, Camarillo began utilizing electric shock therapy and adopted prefrontal lobotomy surgery to eliminate excess emotion and stabilize personalities. One interesting case occurred at Patten State Hospital, where a 29-year-old woman, who, before the surgery spoke only Spanish, began speaking English after the surgery. Walter Freeman, known as the "father" of the lobotomy, created the infamous procedure that involved hammering an icepick-like instrument into a patient's brain through their eye sockets. Dr. Freeman later created the transorbital lobotomy, which he considered a "new, improved" version of the original procedure. Dr. Freeman performed Rosemary Kennedy's lobotomy in 1941. (Both, courtesy CSUCI.)

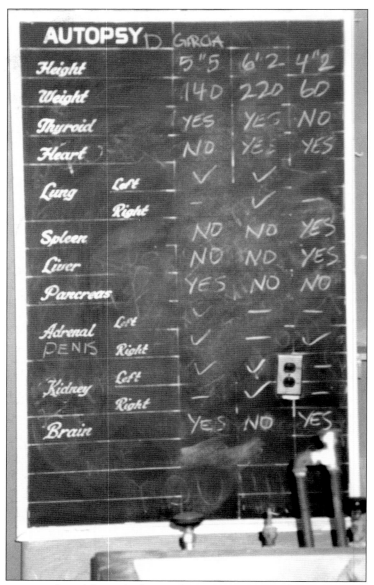

Although this autopsy board from the hospital morgue is a reminder of the inevitable, doctors there strived to improve and advance their patients' lives. In 1956, a special research study for a new tranquilizer drug, Miltown, was conducted at Camarillo with 50 volunteers. Patients participating in the study were divided into one control and one experimental group, with the experimental group receiving the Miltown and the other group given a placebo. Miltown, the first minor tranquilizer, was accidentally discovered by Frank Berger, a scientist from West Bohemia, after he fled the Nazis in 1938. He was attempting to preserve penicillin and stumbled upon mephenesin, a relaxant that would eventually lead to Miltown. According to *On Drugs* on CBC radio, Miltown became very popular in Hollywood during the mid-1950s. The pills were "passed around like peanuts" at parties frequented by celebrities. There were even "miltinis," cocktails with Cold War–inspired names that combined alcohol with the pills, said radio host Geoff Turner. (Courtesy CSUCI.)

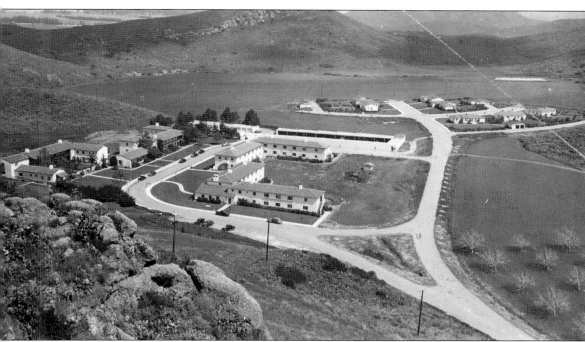

The attendants' quarters (apartments) were built in 1936, with the physician homes coming in a bit later and continuing until the early 1950s. Like the patient housing, housing for staff was never quite adequate, and many were forced to look to nearby towns for residence. As early as 1937, Dr. Thomas Hagerty, superintendent, faced an upcoming shortage for 75 families and 20 doctors and implored the Oxnard Chamber of Commerce for help. The city's housing committee attempted to draw interest in the apartments, which would rent for $20 a month. Plans were drawn for houses for 10 families at the cost of $12,000, but there was no favorable response. Dr. Hagerty predicted that unless nearby cities were able to provide housing for physicians in particular who wished to live off of hospital grounds, Camarillo would have no choice but to provide accommodations in a "colony" on institution grounds. This is, of course, what happened. Dr. Hagerty believed that shortages in housing continually inhibited the hospital's ability to hire enough staff. (Courtesy MS.)

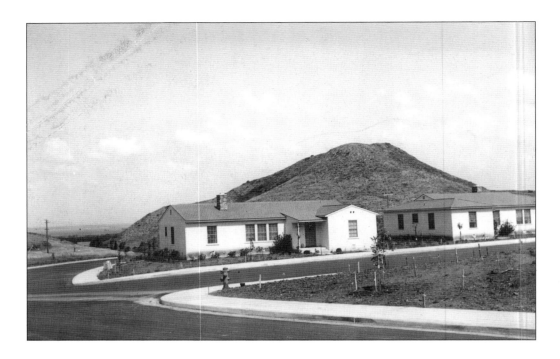

In 1950, there were 10,586,223 persons living in California. In Ventura County, where the hospital was located, there were 114,647. In just 10 years, the county would increase in population by almost 65 percent. The hospital became its largest employer, and with the completion of the Conejo Grade (Ventura Freeway 101), employees could travel to and from Los Angeles within an hour. Still, housing options remained low in neighboring cities for those not involved in agriculture until the 1960s, when housing tracts appeared. Seen here are examples of the physician housing around 1940. (Both, courtesy MS.)

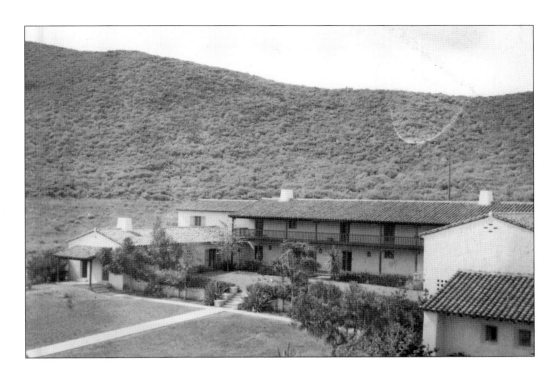

In August 1941, the hospital added $45,000 into the Oxnard City District for payroll regarding its 375 workers and 230 attendants. It was expected that at least 60 attendants would join the hospital, within the next six months. Two years later, there were approximately 400 employees with a monthly payroll of $70,000. In April 1948, a contract for $156,860 for construction of attendants' quarters and garages was awarded additional employees' quarters for 21 married couples and 36 single persons, along with nine physician homes and farmworker housing were completed by the following year. (Both, courtesy MS.)

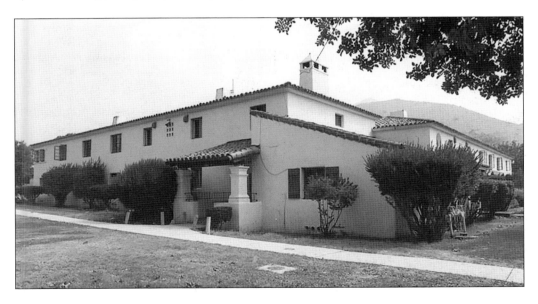

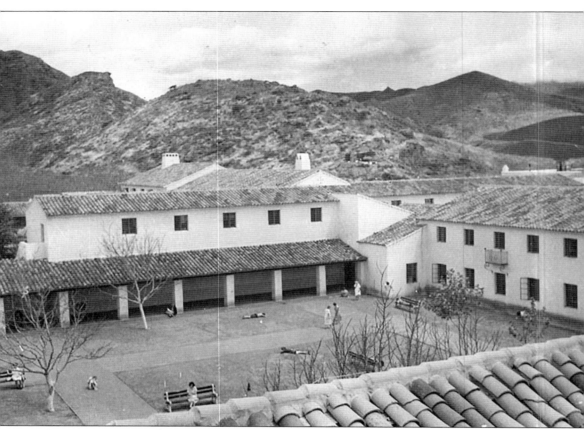

In 1949, Superintendent Hagerty lamented, "The substance of needs for the hospital are more buildings and more doctors, giving a higher ratio of doctor to patient." He continued, "It is impossible for one of our seventeen doctors to give as much treatment as is desired to his several hundred patients." Nine years later, Camarillo had 6,753 patients, 3,218 men, and 3,535 women (North Quad, pictured), with one of the highest turnovers in the nation. Admissions ran about 4,000 annual, and releases were approximately 3,000. The hospital operated on an $11 million-per-year budget, with $7,000 of the operating costs allocated to personnel wages and salaries. Specialties included gynecology, internal medicine, obstetrics, pathology, radiology, and surgery. Ancillary services included clinical psychology, rehabilitation, and psychiatric social work. As of 1957, Camarillo was the largest mental institution in the state. (Courtesy CSUCI.)

Three

FROM INSANITY TO INNOVATION TO INTERLUDE

1960–1997

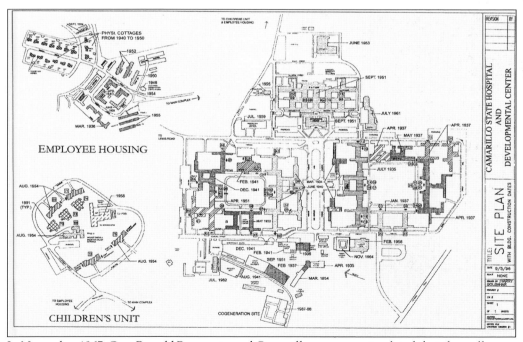

In November 1967, Gov. Ronald Reagan toured Camarillo as rumors circulated that the walls were recently painted, the grass dyed green, and the floors polished until they gleamed. In response to the "sprucing up" chatter, Governor Reagan commented, "I certainly think that any place, even when you visit your in-laws, they sweep the carpet and polish things up and wash the windows." Seen here is a 1996 map of the completion of buildings. (Courtesy CSUCI and CSA.)

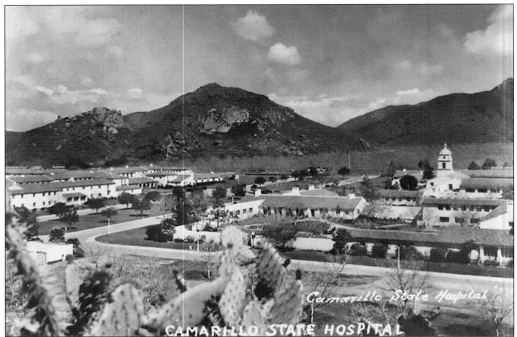

Home to more than 50 productions, Camarillo served as a backdrop to such television series as *Buffy the Vampire Slayer* and *The X-Files*, as well as supplying campus sites to various commercials and music videos, including NSYNC's "I Drive Myself Crazy." A few of the movies filmed at Camarillo include *The Snake Pit* (1949), *A Dangerous Woman* (1993), *Bottle Rocket* (1996), *Manic* (2000), *Pearl Harbor* (2001), *Say It Isn't So* (2001), *The Ring* (2002), *The First 20 Million Is the Hardest* (2002), *Path to War* (2002), *The Shape of Things* (2003), *Jarhead* (2005), *Nick Cannon: Underclassman Undercover* (2005), and *Only the Brave* (2017). In 1974, the movie *Larry* was filmed almost entirely at the hospital; fitting, as it was a story about a former patient. Series filmed there include HBO's *Carnivale* and NBC's *Biggest Loser.* (Both, courtesy CSA.)

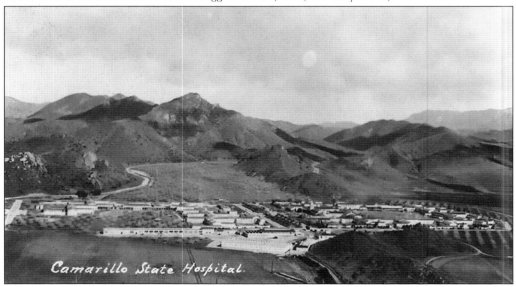

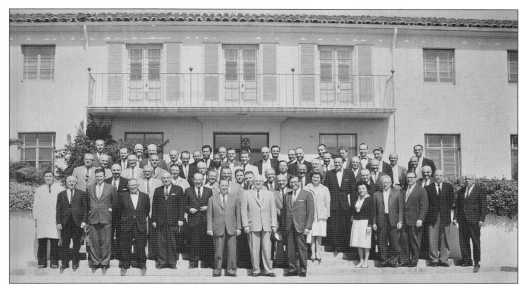

Pictured are two decades of hospital staff in front of the original administration building, c. 1950 above and c. 1960 below. Camarillo's superintendent/executive directors were as follows: Thomas Hagerty, 1936–1949; Franklin. H. Garrett, 1949–1963; Louis Nash, 1963–1968; Vernon Bugh, 1968–1972; Chuck Allen,1972–1973; Harry Jones, 1974–1976; Martin Gish, 1976–1976; Clinton Rush, 1977–1984; Frank Turley, 1984–1992; and David Freehauf, 1992–closing. "Staff" did not always refer to paid workers at Camarillo; in 1968, approximately 50 young adults worked and lived for eight weeks under the Youth Opportunity Unlimited (YOU) program. They were all from Los Angeles, 18 to 21 years old, with no prior job experience. Some were placed in classrooms, some in food services, and some in social services while others worked on the grounds or in maintenance. Four trainees in the hospital television studio wrote, produced, and directed their own variety program, *Saturday Night Special*. (Above, courtesy CSUCI; below, courtesy CSA.)

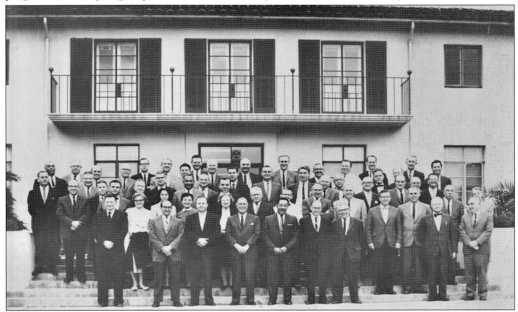

In 1957, California's Assembly Ways and Means Committee added $386,214 to the state's proposed budget for construction of three chapels at Camarillo. Gov. Edmund Brown attended the dedication of the first chapel in 1962. Traditional services were offered in the Catholic, Jewish, and Protestant religions to both staff and patients. A patient-based faith Bible class was later added, which averaged 125 patients per evening. Clergy often served as ministering guests at other locations in the area and often brought the hospital choir along for spiritual entertainment. In 1996, the three full-time clergies ministered to 860 patients. (Left, courtesy CSUCI; below, courtesy CSA.)

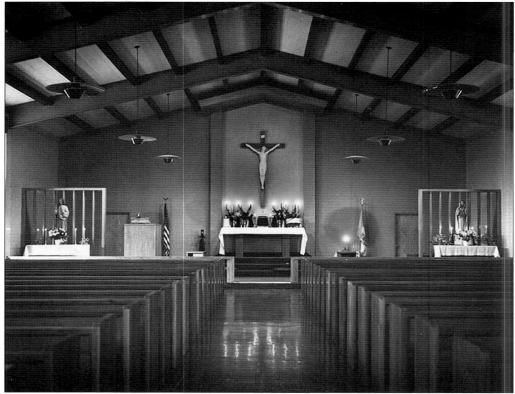

In 1959, two main objectives of the Department of Mental Hygiene were to ascertain what social and personal factors resulted in a patient's return to the hospital and to strengthen social interaction between the patient and his or her local community facilities. "We want treatment to be closer to home, with more social interaction between the patient and his or her own community," stated Dr. Daniel Blaine, who added that the department was against adding extra hospital beds. Approximately 75 percent of the mentally ill patients left state institutions within three months. Twenty percent of these returned later, however; many of them were trial releases. Pictured below is the psychiatric tech class of 1990. (Right, courtesy CSUCI; below, courtesy Martha Hense.)

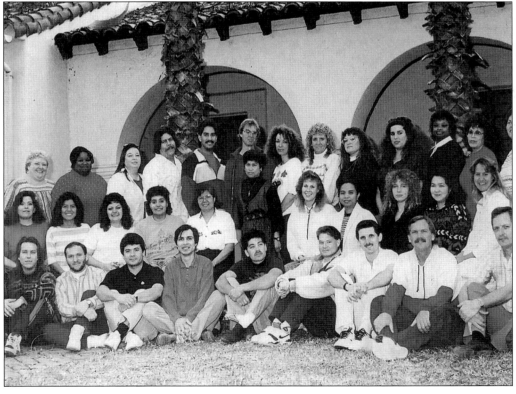

STATE HOSPITALS FOR THE MENTALLY DISABLED
IDENTIFIED POPULATION BY HOSPITAL
June 30, 1951 through Present

Fiscal Year Ending June 30	Total All Hospitals	Agnews	Atascadero	Camarillo	DeWitt	Mendocino	Metropolitan	Modesto	Napa	Patton	Stockton
1931	15,799	2,178				1,835	2,112		2,988	3,361	3,325
1932	16,754	2,362				1,941	2,253		3,130	3,600	3,465
1933	17,693	2,798				2,407	2,262		3,122	3,634	3,470
1934	18,546	3,061				2,664	2,276		3,281	3,768	3,496
1935	19,437	3,241				2,669	2,483		3,361	3,959	3,624
1936	20,105	3,373		1,082		2,750	2,559		3,466	4,084	3,782
1937	20,737	3,395		2,008		2,759	2,362		3,465	3,955	3,800
1938	21,834	3,499		2,353		2,786	2,435		3,605	3,572	3,979
1939	22,608	3,525		2,508		2,790	2,327		3,639	3,843	4,130
1940	22,953	3,552				2,712	2,305		3,574	3,913	4,389
1941	23,345	3,408		2,778		2,722	2,344		3,465	3,988	4,560
1942	23,617	3,458		3,627		2,643	2,308		3,753	3,613	4,415
1943	24,240	3,552		3,829		2,908	2,257		3,826	3,642	4,201
1944	24,903	3,627		4,015		2,891	2,407		3,830	3,800	4,273
1945	25,830	3,818		4,274		2,891	2,454		3,965	4,095	4,353
1946	25,328	3,607		4,451		2,997	2,517		4,097	4,319	4,400
1947	27,544	3,612		4,698	1,933	2,891	2,491		4,025	4,394	4,240
1948	29,049	3,452		4,633	1,814	2,788	2,430	2,010	3,843	4,062	4,011
1949	30,501	3,544		4,820	1,869	2,818	2,457	2,294	3,977	4,106	4,596
1950	31,863	3,726		5,262	2,054	2,776	2,372	2,505	4,211	4,135	4,684
1951	32,731	3,986		5,550	2,750	2,711	2,515	2,460	4,563	4,209	4,589
1952	33,637	4,620		6,224	2,730	2,602	2,377	2,372	4,534	4,332	4,497
1953	35,276	4,580		6,761	2,223	2,635	2,539	2,547	4,752	4,496	4,703
1954	36,123	4,764	120	7,266	2,758	2,490	2,459	2,639	5,094	4,628	4,505
1955	36,927	4,508	1,162	6,990	2,390	2,270	2,263	2,852	5,392	4,525	4,567
1956	37,091	4,399	1,109	7,242	2,300	2,305	2,291	2,916	5,326	4,317	4,878
1957	37,076	4,392	1,179	6,758	2,469	2,237	2,449	3,044	5,597	4,366	4,623
1958	36,979	4,095	1,161	6,828	2,477	2,456	2,880	2,867	5,664	4,259	4,352
1959	37,489	4,095	1,221	6,610	2,446	2,421	3,109	2,618	5,951	4,339	4,077
1960	36,853	4,180	1,389	6,404	2,314	2,330	3,907	2,339	5,322	4,819	3,819
1961	36,048	4,184	1,540	6,378	1,979	2,261	3,920	2,353	5,070	4,752	3,871
1962	35,743	4,347	1,617	6,332	1,288	2,302	4,140	2,399	5,173	4,438	3,707
1963	34,995	4,262	1,631	6,266	1,127	2,264	4,099	2,378	5,040	4,379	3,568
1964	32,622	4,161	1,604	5,279	1,093	2,061	3,680	2,071	4,771	3,943	3,319
1965	30,765	3,864	1,504	5,449	1,070	1,815	3,629	2,045	4,451	3,782	3,034
1966	26,557	3,759	1,641	4,791	914	1,715	3,134	1,706	4,005	2,775	2,777
1967	21,966	2,413	1,566	3,690	700	1,590	2,857	1,416	3,527	2,075	2,322
1968	18,831	1,950	1,329	2,748	681	1,538	2,443	1,196	3,007	2,250	1,729
1969	16,116	1,472	1,322	2,388	664	1,308	2,052	1,087	2,745	1,567	1,391
1970	12,671	1,150	1,354	2,155	354	1,115	1,828	6	2,038	1,604	1,285

Atascadero admitted patients beginning in 1954.
Hospital closed.
Includes 100 patients in 1935 and 101 in 1936 on...

As of February 1959, there were 36,319 mentally ill and 46,526 developmentally disabled persons in the California state hospital system. Dr. Daniel Blaine, the new head of the State Department of Mental Hygiene, expressed his belief that a "day hospital provides beds for rest, a mid-day meal, and medical and surgical equipment" and should be able to treat the patient on-site and not forward him or her on to a state hospital. He also expressed that studies were needed to show how mental hospitals "spent their time and utilized their skills in order to make the best use of what they had." According to Dr. Blaine, "Shortage of personnel is probably the most serious mental health problem in the entire country. . . . Our department needs to persuade a larger percentage of nurses to enter into our service." (Left, courtesy CSUCI; below, courtesy Sherry Warrick.)

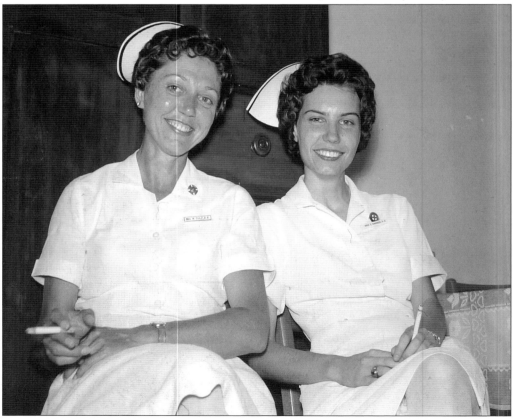

70

What goes on in the brain of a mentally ill person? In early 1960, a research project at the hospital conducted by Dr. John Woodard, director of the neuropathic research library, studied the brain using photo micrographics, or pictures taken through a microscope. It had only recently been discovered that the reticular activating system of the brain, which is a group of cells in the brainstem, determine consciousness. Camarillo was the only hospital in the country at the time interested in examining this area and its relation to mental issues. John Dryer, head of the medical photography department, who had worked with Boris Karloff, among other notable actors, assisted Dr. Woodard by taking photographs of the brain and viscera to be autopsied. The hospital autopsy/observation room and cadaver storage were located in the basement of the RT Building. (Both, courtesy Frank Beruecos.)

Real monkeys or people only acting like monkeys? This mural of the Marx Brothers found in the North Quad's Walk of Fame pays tribute to Camarillo and its association with the entertainment world. Notable hospital patients included Ad Wolgast (1936), lightweight boxer; Charlie Parker (1945), jazz musician (who released a composition entitled "Relaxin' at Camarillo"); Hal Grayson (1948, 1954), bandleader; Craig Rice (1949, 1950), mystery writer; Charles Lloyd (1948), actor; Pauline Evans (1950), actress; Dorothy Comingore (1953), actress; Della Shaw (1953), actress; Dale Hall (1953), heavyweight boxer; Bela Lugosi (1955), actor; Francis Gifford (1958), actress; Barbara Burns (1961), actress; Keeny Teran (1962), bantamweight boxer; Gia Scalia (1971), model and actress; and Pete Pontrelli (1993), orchestra leader and musician. The majority of artists became patients at Camarillo for only short periods of time, often battling alcoholism or drug abuse. (Left, courtesy Steve Axtell; below, courtesy Ben Hipple.)

In 1961, Los Angeles businessman Perry Whiting, owner of Los Angeles Building Supply Company, who was once a patient at Camarillo in the 1940s, willed $98,465.90 to the hospital to be "used for the benefit of the patients." The Perry Whiting Swimming Pool was constructed and located near the South Quad next to Hagerty Gym. It was demolished in 2004 to make room for a university science building. (Courtesy CSUCI.)

Pictured here is state senator Robert Lagomarsino, who introduced a bill in 1965 for the establishment of a state college in Ventura County. By December 1966, the trustees narrowed their choice of sites to 19 acres of property controlled by the hospital. Ultimately, the next state college would be located north in the city of Bakersfield. In 1972, the State College System became the California State Universities. (Courtesy CSUCI.)

CAMARILLO STATE HOSPITAL AND DEVELOPMENTAL CENTER
MEDICAL, DENTAL AND PHARMACY STAFF
OCTOBER 6, 1993

In the early 1960s, Camarillo began to recognize the patient "as a person who is not ill all over or all the time . . . instead of doing things for the patient all the time, we are doing things with him," according to Dr. Philip May, hospital research director. A patients' organization was established which acted as a governing body, where each ward had its own constitution and elected officers who lead weekly meetings. Four units (12–15 wards) also had a representative body, made up of delegates. The units sent delegates to a central committee, whose function was to handle hospital-wide problems. To eliminate visual authoritarian barriers and encourage an inviting, non-threatening environment, the staff replaced traditional uniforms with street clothes, as depicted in the above photograph of the medical, dental, and pharmacy staff of 1993. (Both, courtesy CSUCI.)

As early as 1963, Camarillo addressed unemployment issues experienced by former patients who were unsuccessful obtaining employment in the community. A rehabilitation program, established with the assistance of the Jewish Vocational Services, decided to utilize the hospital bakery as an instrument of teaching for 120 men, ages 18 to 45. A trained vocational counselor supervised the workshops. The patients learned not only the art of baking but also, more importantly, socialization skills, such as how to get along with fellow workers and supervisors and how to overcome the fear of making mistakes. Other on-the-job training projects included groundskeeping, janitorial, painting, sewing, and upholstery. (Both, courtesy CSUCI.)

Camarillo was one of five state hospitals in 1963 studying ways to detect very early congenital deformities. In particular, doctors looked at phenylketonuria, found in approximately 1 out of 20,000 children, which is a rare, inherited defect in the enzyme system. They discovered that a build-up of the amino acid phenylalanine causes brain damage, but that management is possible, with the elimination of certain proteins from the baby's diet. (Courtesy CSUCI and Judy Lucas.)

In 1969, the Spinal Cord Research Foundation and its local subsidiary, the Backers, supported a pilot project at Camarillo to determine if spinal ailments and deformities had any connection with developmental disabilities or mental illness. The Backers sponsored this first-ever-conducted research with several gala fundraisers held by the women's group, who hoped the endeavor would facilitate medical regeneration of damaged spinal nerves. (Courtesy CSUCI.)

Wind chimes such as these, were patient-made and often for sale at various exhibitions. Developmentally disabled patients participated in the Work Training Center, which originated in 1967 with 10 patients. Patients learned how to use packaging machinery to shrink-wrap and blister pack for local business products. Patients also separated plastic cutlery, packaged balloons, assembled simple computer components and drug-test kits, and labeled wine bottles. The workshops operated in factory settings, with a time clock, hourly wage, and paid holidays and vacations. Over 120 patients participated at any one time, working for outside vendors, such as 3M and Jafra. The operation paid for itself, generating approximately $230,000 a year. (Both, courtesy CSUCI.)

VOCATIONAL SERVICES

Is a State operated program offering employment and Vocational Education services to the Developmental and Mentally Disabled.

OUR PURPOSE

To assist each individual to move as far as possible along a continuum from vocational dysfunctions to renumerative employment and entry into the main-stream of society as an independent citizen and worker.

WORK ADJUSTMENT

Training area involves an introduction to work environment through community awareness activities. Focusing on the practical skills needed for job acquisition and job maintenance. Emphasis is placed on Interpersonal and Communication Skills and knowledge of work practices as determined by Criterion-References and Norm-Referenced Assessments.

WORK TRAINING CENTERS

Many different types of work are being done for a variety of companies by our clients. This includes the use of packaging machinery: shrink wrapping, blister packing and skin packaging products. Other jobs are inspecting, cleaning, assembling, collating, recycling and wine labeling. Production of ceramic wind chimes is a proprietary product.

TRANSITIONAL AREA

The transitional area was instituted to assist the clients that needed more help in making the move from the classroom to the work setting a positive experience.



Pictured is the hospital courtroom in the South Quad. The Lanterman-Petris-Short (LPS) Act of 1969 removed the state's responsibility of providing mental health care by transferring it to counties with at least 100,000 residents. A pre-screening process determined what type of care was required. LPS required that for involuntary hospitalization, a person must be dangerous to himself, dangerous to others, or unable to provide himself with food, clothing, or shelter because of a mental disorder. The legislation also provided for strict time limitations for involuntary hospitalization, an initial 72-hour period for evaluation and treatment, and 14 days for intensive treatment. A judge, secretary, bailiff, public defender, and deputy district attorney conducted court proceedings to provide hospital clients with the right of due process. Most of the hearings involved writs of habeas corpus—that is, patients requesting release from the hospital. (Above, courtesy Mary E. Holt; left, courtesy CSUCI.)

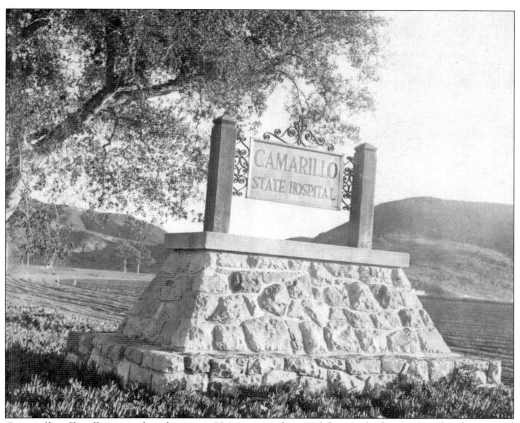

Camarillo officially opened its doors in 1936 as a state hospital, but in the late 1960s, developmental programs were initiated in all state hospitals, giving each institution a dual purpose of treating both the developmentally disabled and the mentally ill. In 1968–1969, Camarillo housed 451 developmentally disabled clients and 2,505 mentally ill clients, with a budget of $19,199.875. Just a few short years later, in 1974–1975, patient beds numbered 633 for the developmentally disabled and 1,478 for mentally ill clients, with a budget of $30,452.376. In November 1977, Camarillo became the first of the state institutions to receive certification for the care of the developmentally disabled. Pictured are the 1970 (above) and 1996 (below) entrance signs. (Above, courtesy TO; below, courtesy Diana Patton.)

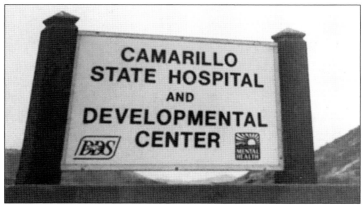

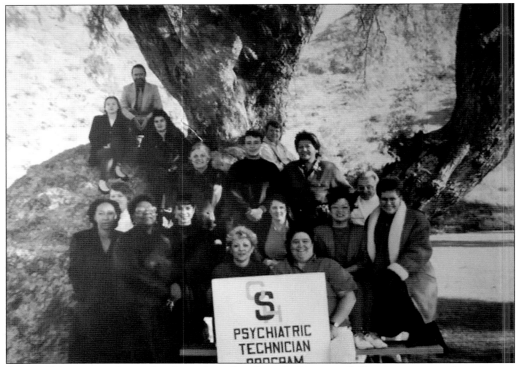

Camarillo's variety of specialized care benefitted nearby Ventura College's nursing and psychiatric technician programs. The psych tech program, which began in 1971, trained approximately 90 students. It was a yearlong program, where students spent 10–12 hours a week studying and 26 hours per week working at the hospital. The program included four to five courses in psychiatric and mental health technology, two in physical care, and four in behavioral sciences. Students were under the supervision of one instructor and worked with the nursing team on hospital wards. In 1977, a comprehensive training program began, with an initial four-week candidacy period and then 582 hours of classroom instruction and 1,082 hours of laboratory training packed into 48 weeks. Students also received instruction in behavioral science and nursing science/pharmacology. Class size ranged from 30–40 students. Pictured here are psychiatric techs, class of 1991 (above), and nursing striping ceremony, 1982 (below). (Above, courtesy Brenda Schell; below, courtesy Anthony Casello.)

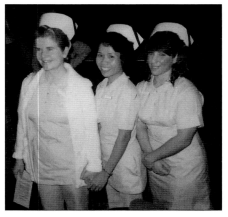

CAMARILLO-UCLA CLINICAL RESEARCH UNIT

The Camarillo-UCLA Clinical Research Unit is a joint public-academic program of Camarillo State Hospital and the UCLA Department of Psychiatry & Biobehavioral Sciences. Its primary aim is to develop, validate, and disseminate new and effective treatments for persons with serious mental and developmental disabilities.

Since 1970, research has been conducted on behavioral, social, and family influences on schizophrenia and other major mental and developmental disorders. The Clinical Research Unit more recently has attracted neuroscientists specializing in cognitive, psychophar-macological, and psychophysiological methods of assessment and treatment. The Camarillo-UCLA Clinical Research Unit has published more studies on mental illness in its twenty-five years than any other state hospital research program in the country.

Robert Paul Liberman, M.D.
Director

The Camarillo-UCLA Clinical Research Unit was presented with the State-University Collaboration Award by the American Psychiatric Association at the annual Institute of Hospital & Community Psychiatry in October 1991. This award was given in recognition of the research productivity of the CRU over two decades, the propagation of the benefits of this research nationally and internationally through products, publications, and consultations, and the high quality of its clinical programs.

Robert Paul Liberman, M.D., Director of the CRU since 1970, has an international reputation for the development of successful and innovative biobehavioral treatment programs. Hundreds of hospitals and mental health systems around the world have adopted the training methods for rehabilitating persons with schizophrenia that were developed by Dr. Liberman and his colleagues at the CRU. Modules for training social and independent living skills have been translated into French, Italian, German, Polish, Bulgarian, Norwegian, Swedish, Finnish, Japanese, Chinese, and Korean.

Dr. Liberman's contributions to research and the advancement of patient care have merited formal recognition from a number of national and international organizations including the National Alliance for the Mentally Ill, Award for Exemplary Psychiatrist; the American Psychiatric Association, Hibbs Award for Innovations in Treatment, Van Ameringen Award for Psychiatric Rehabilitation, and Award for Outstanding Achievement for the Social and Independent Living Skills Program; the American Academy of Psychoanalysis, Schizophrenia Research Award; the World Association for Psychosocial Rehabilitation, Superior Achievement Award; and Honorary Memberships in the Polish, French, and Swedish Psychiatric Associations.

The Clinical Research Unit, a 12-bed, inpatient facility for mentally ill and mentally disabled patients, was a joint effort between the Department of Psychiatry at the University of California, Los Angeles School of Medicine, and Camarillo State Hospital. Its objective was to synchronize applied research, meaningful training, and effective treatment within an interdisciplinary framework. Dr. Robert Liberman, director of the Unit since 1970, created methods that focused on social and independent living skills to rehabilitate schizophrenic persons. The unit, which saw over 500 patients during its time, published more studies on mental illness in its 25 years than any state hospital research program in the country. About half of its patients left after treatment. The partnership with the University of California, Los Angeles (UCLA) and Camarillo's Unit 45 was the most productive of any in the United States. (Both, courtesy CSUCI.)

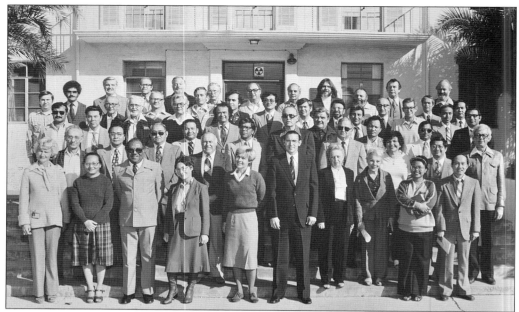

Seen here is the first administration building completed, front view (above) and rear view (below) around 1990. By the fall of 1974, Ventura College and Camarillo developed an adult school program for approximately 140 developmentally disabled adults residing at the hospital. The college provided staffing for the program, and the hospital provided space, equipment, and supplies. Such residents were previously denied their educational rights by the outside school system because the districts did not have special education programs in place. Students were subsequently tested and assigned to classes, which included sensory and perceptual motor development, math, reading, physical education, and basic job skills. (Above, courtesy CSUCI; below, courtesy CSUCI and Judy Lucas.)

Scientific research conducted by the hospital's Neuropsychiatric Research Program, under the direction of Robert H. Coombs (jointly supported by the UCLA School of Medicine), led to several authored manuscripts and books during the 1970s. In fact, "Socialization in Drug Abuse," "Effective Parents, Responsible Children," "Mastering Medicine," and "Making It in Medical School" were just a few of the scientific topics that went into press, along with numerous professional research journals and doctoral dissertations written by psychology interns. Topics included aggression, autism, cancer, childhood psychosis, death and dying, delusional and hallucinatory speech, depression, drug abuse, neurotic depression, psychotic behavior, self-destructive behavior, and schizophrenia. (Right, courtesy Sherry Warrick; below, courtesy CSUCI and Judy Lucas.)

The hospital's volunteer program began in 1942, with the foster grandparent program initiating 30 years later. The grandparents, age 60 and over, worked four hours a day, five days a week, receiving a stipend of $1.60 an hour, plus $1.75 a day, transportation fees, as well as a hot lunch. Nine state hospitals had foster grandparents, with approximately 50 at Camarillo. Actress (and future first lady) Nancy Reagan paid tribute to Camarillo's foster grandparents at their second annual Reason Day program on October 22, 1974, by presenting each grandparent with a certificate of accomplishment. The program featured Richard Dawson, host of television's *Masquerade Party*; singer Judy Donovan as mistress of ceremonies; and vocalist Keith Evans. "It's my foster grandchild who keeps me going and gives me a purpose for living," said one foster grandmother. (Both, courtesy CSUCI.)

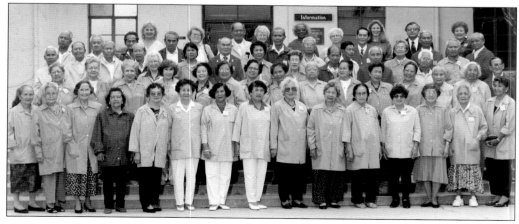

An investigation began in 1971 into the case of a 71-year-old man who spent half of his life in state hospitals for no documented reason. Huey Kim Dock boarded the USS *Cleveland* in China, leaving behind a wife and a child, and arrived in San Francisco in 1924. He worked as a grocery clerk for 11 years but was committed by his cousin to the Stockton State Hospital in 1935. He was later transferred after 25 years to Patton, where he spent two years, and then to Camarillo in 1962. Dock's conversations with Camarillo personnel were almost nonexistent, as he spoke only traditional Cantonese. His English was limited to "cigarette please" and "match." During his reevaluation regarding further commitment under the Mental Health Act of 1967, his attorney advertised the language predicament. The case caught the attention of nearby restaurateur Wellman Jue, and for the first time in over 30 years, Dock was able to carry on a complete conversation in his native tongue. Eventually, he relocated to a care facility in San Francisco. (Courtesy Mary E. Holt.)

As early as 1973, plans were in place to close Camarillo. Gov. Ronald Reagan initially decided to phase out all state hospitals and replace them with community-based facilities, such as local care homes, nursing homes, or other county facilities, which would be financed 90 percent by the state. Preliminary plans called for the phasing out of the 11 remaining hospitals in a 10-year period by systemically decreasing the patient population. Despite statewide protest, the state asserted that the hospitals would continue operating only "for the foreseeable future." When Governor Reagan took office in 1967, there were 15 state hospitals. Four closed shortly thereafter. Pictured are hydrotherapy baths utilized for patient therapy. (Both, courtesy Frank Beruecos.)

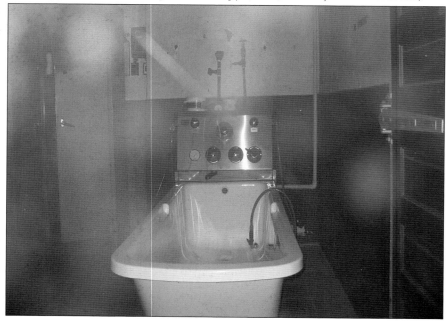

Astronaut James Lovell, of Apollo 13 fame, visited 200 Los Angeles County high school students during a workshop on drug abuse at Camarillo State Hospital in November 1979. Camarillo's adult alcohol abuse program was open 24 hours a day, offering a two-phase program for chronically ill alcoholics, ages 18–60, who had psychiatric complications and needed extended inpatient care. Abusers were required to attend educational discussions and were gradually re-introduced into the community-at-large. The adult drug abuse program, rated the most successful in the state, included a three-phase program, offering detoxification for eight days and then, the option of either entering a 90-day program embodying therapeutic community principals or an 8-to-12-month residential treatment embodying Synanon and Mendocino ("the Family") methodology. (Courtesy TO.)

In 1977, Russell Lockhart, director of the Camarillo Neuropsychiatric Institute Research Program, studied the dreams of cancer patients in 1977 to explore a possible relationship between dreams and diseases. He questioned if there was a correlation between the type and nature of a dream and a disease, whether dreams are prognostic, and if dreaming can actually aid treatment. (Courtesy Mary E. Holt.)

CAMARILLO STATE HOSPITAL
Enhancing Independence Through Innovation

In October 1990, a total of 10 Soviet psychiatrists toured Camarillo to learn about US treatments of schizophrenia and in particular, patients' rights and civil liberties. After the visit, Dr. Robert Liberman, director of the Clinical Research Center for Schizophrenia and Psychiatric Rehabilitation, commented that the World Psychiatric Association had expelled the Soviet Union's Psychiatric Society in 1984, accusing it of placing political dissidents in mental institutions. (Courtesy CSUCI.)

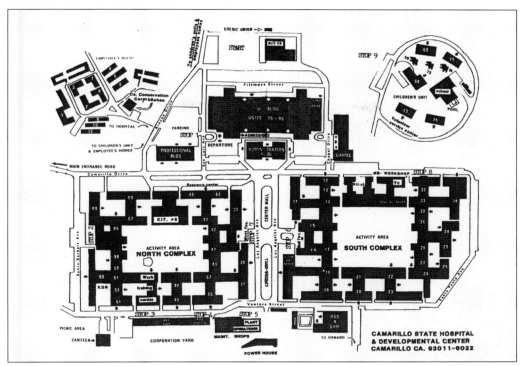

Pictured are hospital maps from around 1996 (above) and 1981 (below). Camarillo was licensed in 1975, the first year for state hospitals. Its programs included a behavior adjustment program, a geropsychiatry and multiple-handicapped adult program, a habilitation program, an intensive psychiatric intervention program, a medical-surgical program, a physical and social development program, a self-help program, a sensory deprivation program, and a substance abuse program, among others. Public Law 94-142 (Education of Handicapped Children Act, 1977) required that all handicapped persons between the ages of 3 and 21 receive "a free, appropriate public education in the least restrictive environment." Camarillo provided educational

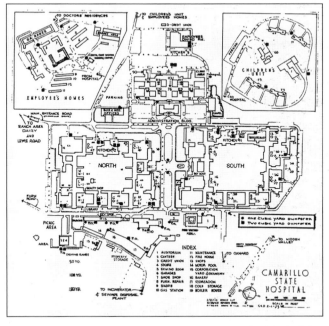

services to approximately 95 autistic residents and approximately 35 developmentally disabled adults. The year-round program employed 12 teachers credentialed to work with severely handicapped students. Nearby Ventura College also provided additional instructors for a joint adult education program. (Both, courtesy CSUCI.)

The Accreditation Council
on Services for People with Developmental Disabilities

Awards this

CERTIFICATE OF ACCREDITATION

to

Camarillo Developmental Center

In recognition of demonstrated commitment to
providing services of high quality and in substantial compliance with
Standards for Services for People with Developmental Disabilities.

Agency Accredited

From
5-27-88

Until
5-27-90

Mary C. Cerreto
EXECUTIVE DIRECTOR

Edward Tourin
CHAIRMAN OF THE BOARD

This certificate is the property of the Accreditation Council

In its 60 years of existence, Camarillo achieved a variety of national recognitions. In 1960, it received the Bronze Award from the American Psychiatric Association. Twelve years later, under the direction of Dr. Philip R.A. May, researchers proved the superiority of phenothiazines (antipsychotics) in battling schizophrenia. In 1974, the Cancer Commission of the American College of Surgeons approved Camarillo as a Category "S" hospital, a special type of hospital that served particular age groups—in this case, children, who developed cancer. In 1977, it was awarded a $247,803 grant from the National Institute on Drug Abuse to provide an educational framework for a family approach to substance abuse prevention and early intervention, using positive reinforcement. Later that year, Camarillo became the first of the state's institutions to receive certification for the care of the developmentally disabled. In 1987, it was accredited by the Joint Commission on the Accreditation of Hospitals. Fewer than 25 percent of the nation's mental hospitals met the requirements. (Courtesy CSUCI.)

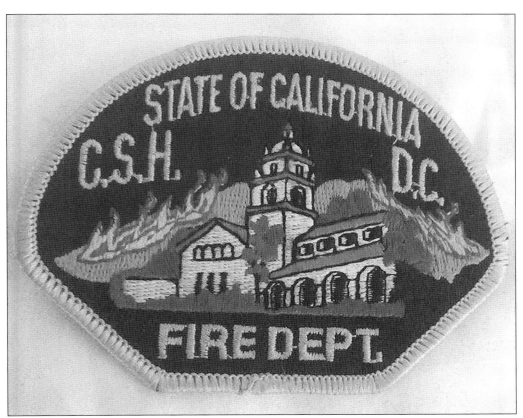

There was rarely a dull moment for Camarillo fire department personnel, Station 59, throughout the hospital years. In October 1935, the new hospital faced down a ground fire, while a warehouse fire, started by a patient and a book of matches in the summer of 1959, caused approximately $100,000 in damage and left the hospital lacking bedding, clothing, and maintenance equipment. In 1975, an unknown source fire created $250,000 of damage to an office, the Hagerty Auditorium, and a recreational building. Lost were musical instruments, arts and crafts materials, phonograph records, and books. One year later, the Potrero Fire roared down 2,000 acres and came dangerously close to staff housing and the children's area. In 1986, an employee set fire to her 36-unit apartment building. One resident jumped from the roof, while another was airlifted out of the flames. (Above, courtesy Gary Cole; right, courtesy Barbara Price.)

Hospital police protected and served not only the staff of Camarillo but also its patients. Camarillo's Program 9, behavior therapy and social learning, aided patients who were developmentally disabled and in some manner, were involved in the criminal justice system and received a psychiatric diagnosis. (Courtesy Gary Cole.)

Occasionally, patients got into trouble. For instance, one incident in March 1996 involved an escapee who managed to climb a 150-foot electrical tower. Fortunately, Edison crews shut off the 220,000-volt power line. In January 1977, hospital police and fire chased after a patient who had crawled through a 1,200-foot-long pipe near the entrance road to avoid capture. Personnel literally tunneled in after the escapee, who kept ahead of them until the pipe was cut from above ground and the patient pulled out. (Courtesy CSUCI.)

SUPERIOR COURT OF THE STATE OF CALIFORNIA Page 7

FOR THE COUNTY OF _____

The People of the State of California Concerning NO. _____

_____ NOTICE OF
 Respondent CERTIFICATION

The authorized agency providing evaluation services in the County of _____ has evaluated the condition of:

Name _____ Date of birth _____ Sex _____

Address _____

Marital status _____ Religious affliation _____

We, the undersigned, allege that the above-named person is, as a result of a mental disorder or impairment by chronic alcoholism:

* (1) A danger to others.
* (2) A danger to himself.
* (3) Gravely disabled as defined in subdivision (h) of Section 5008 of the Welfare and Institutions Code.
* Strike out all inapplicable classifications.

The above-named person has been informed of this evaluation, and has been advised of, but has not been able or willing to accept referral to, the following services:

We, therefore, certify the above-named person to receive intensive treatment for no more than 14 days beginning this _____ day of _____ , 19 _____ , in the intensive treatment facility herein named

We hereby state that a copy of this notice has been delivered this day to the above-named person and that he has been informed of his legal right to a judicial review by Habeas Corpus, and this term has been explained to him, and that he has been informed of his right to counsel, including court appointed counsel pursuant to Section 5276 of the Welfare and Institutions Code.

We hereby state that a copy of this notice has been delivered by _____ and that the patient, when advised of his rights to a judicial review, (requested such review) (did not request such review).
 (Cross out one)

 Date

Signature _____

Countersignature _____

CONFIDENTIAL PATIENT INFORMATION Original: Superior Court
 See California. W & I Code Sec. 5328 Copies: Person Certified — Personally delivered
 Person's Attorney /Public Defender
STATE OF CALIFORNIA District Attorney
DEPARTMENT OF MENTAL HEALTH Intensive Treatment Facility
FORM MH 1536A (7/78) Department of Mental Health
REF. SEC. 5250 W&I CODE

 NOTICE OF CERTIFICATION

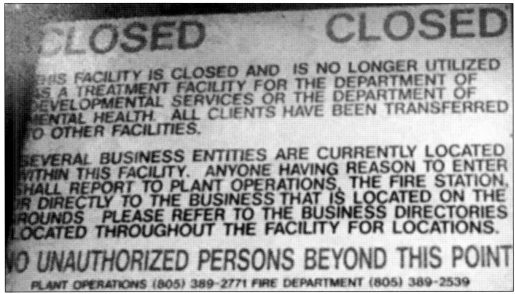

CLOSED CLOSED

THIS FACILITY IS CLOSED AND IS NO LONGER UTILIZED
AS A TREATMENT FACILITY FOR THE DEPARTMENT OF
DEVELOPMENTAL SERVICES OR THE DEPARTMENT OF
MENTAL HEALTH. ALL CLIENTS HAVE BEEN TRANSFERRED
TO OTHER FACILITIES.

SEVERAL BUSINESS ENTITIES ARE CURRENTLY LOCATED
WITHIN THIS FACILITY. ANYONE HAVING REASON TO ENTER
SHALL REPORT TO PLANT OPERATIONS, THE FIRE STATION,
OR DIRECTLY TO THE BUSINESS THAT IS LOCATED ON THE
GROUNDS. PLEASE REFER TO THE BUSINESS DIRECTORIES
LOCATED THROUGHOUT THE FACILITY FOR LOCATIONS.

NO UNAUTHORIZED PERSONS BEYOND THIS POINT

PLANT OPERATIONS (805) 389-2771 FIRE DEPARTMENT (805) 389-2539

Even though technically Camarillo was on the chopping block, the state decided that it would remain open for mentally ill patients until 1977 and for the intellectually disabled until 1982. The hospital trekked on, however, to 1997 with 600 developmentally disabled and 750 mentally ill, but still, the idea of community-based care was too appealing. Suggested options for the site included a reform school, a convalescent hospital, and a minimum-to-medium security prison for mentally disabled sex offenders. None took hold, and in January 1996, Gov. Pete Wilson ordered its closing based on declining population and budget concerns. Officials estimated that the state would save $23 million per year. Despite protests and injunctions, emotions and rationale, on July 1, 1997, the once largest state hospital this side of the Mississippi River lost its 60-year war and shut its doors officially and forever. (Above, courtesy CSUCI and Judy Lucas; below, courtesy Mary E. Holt.)

After Camarillo's closure, its grounds remained in "warm shut-down" from July 1997 to June 1998. In January 1996, J. Handel Evans was appointed planning president of the 23rd campus of the California State University (CSU) system. A year later, Gov. Pete Wilson signed state senator Jack O'Connell's Senate Bill 1923, approving the transfer of the land to the CSU and Senate Bill 623, facilitating finances and support. In 1998, a conveyance ceremony occurred, celebrating Ventura County's first four-year university. CSU Northridge (CSUN)'s satellite campus in the city of Ventura moved to the new site in July 1999 to initiate classes in the fall as CSUN at Channel Islands. In April 2002, Pres. Richard Rush became CSUCI's second president, and in August, California State University Channel Islands held its official opening ceremony. (Both, courtesy CSUCI and Judy Lucas.)

Four

THE CHILDREN'S UNIT
A PLACE OF REFUGE

DEDICATED TO:

Dr. Thomas W. Hagerty, M. D., Supt.,
Camarillo State Hospital

Mr. W. D. Bannister, Principal,
Oxnard Union High School

Physician, Educator, Social Pioneers

They ultimate in deeds these words of Browning's Paracelsus:
"And to know consists rather in opening out a way
Whence the imprisoned splendor may escape;
Than in effecting entry for a light supposed to be without."

HIGHWAY 101

DEAR LORD:—
I WALK ALONG THIS AVENUE OF TREES;
THIS LEAFY COLONNADE-THIS VERDANT TUNNEL
WHERE THE SUNLIGHT SEEMS CONGEALED
AT THE FARTHER OPENING
TREES, FORM THIS GREEN CATHEDRAL ARCH,
ALONG A BUSY HIGHWAY--
TREES, ARMS OVERLAPPED ON SHOULDERS,
SCHOOL-BOY FASHION,
AS THOUGH WHISPERING CONFIDENCES--
DEEP, SIMPLE, SACRED SECRETS.
TREES -- THE EVER-GUARDIAN ACOLYTES -
CAN IT BE IT WAS A TREE THEY USED.
TO CAUSE THEE ANGUISH, LORD?
H.W. KEATING
CAMARILLO CALIF.

In 1939, the hospital began admitting children, who were initially housed in the South Quad, moved to the North Quad in 1949, and moved again to a separate area in late 1955. The program originally consisted of 2 doctors and 60 children, undergoing treatment for emotional and behavior problems. It was the first unit of its kind in a mental hospital west of the Mississippi River. (Courtesy CSUCI.)

A more permanent Children's Unit became a necessity as demand increased, once word spread of the program. Children under the age of 14 were moved to east of the main grounds, beyond the RT Building, in late 1955. In February 1940, another educational experiment took place at Camarillo. Working with Oxnard Union High School, the hospital initiated its own high school, with 50 students, ranging in age from 14 to 19 years old. Classes, with teacher Winifred Keating, were held from 9:00 a.m. to 4:00 p.m. for five days a week. If they were successful through the program, students received a valid graduation certification. These classes were the first ever at a state institution and if deemed a success, would be duplicated by other state hospitals. (Courtesy CSA.)

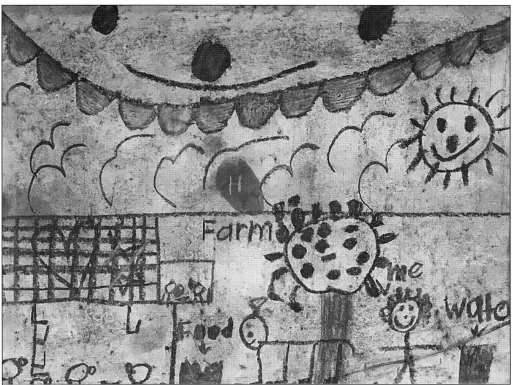

According to Dr. Nash, assistant superintendent, the Children's Unit was established for "the young schizophrenic, the protest-reaction child, and the psychotic, in an attempt to prevent them from becoming a unit of the hospital." At the original Children's Unit, approximately 95 percent of the admissions were for 90 days. The yearly turnover was around 320 children. There were 80 children under 15 and approximately 100 patients between 15 and 21. Children 14 and under were divided by sex. The older children (15–21) were placed with the adults of the same sex and were later brought together on the sole basis of age. There was no segregation among the children who were there for the 90-day period of observation and those who were committed. A new facility was created in September 1955 primarily for the diagnosis of 90-day cases. (Both, courtesy CSUCI.)

Treatment Program

The present composition of the treatment teams and favorable staffing ratio enables this Center to provide diagnostic and intensive treatment services to our children geared to meet their needs. Each treatment team has developed its own treatment program for their unit. There is a considerable difference between a treatment program that has to take into account needs and deficits of younger children, needing to learn basic self-care skills, and a program for pre-adolescent and adolescent boys and girls facing problems related to peer relationships, sexuality, authority, approaching adulthood, etc.

CUB SCOUTS

BIKE SAFETY AND
OBSTACLE COURSE

The programs for withdrawn, psychotic and anxious children are also quite different from the ones needed for pre-delinquent, acting-out, aggressive, adolescent boys and girls. Therefore, dividing children into small homogeneous groups in terms of age, sex, and problems is one of the most essential aspects of our total treatment approach. Since each child is a unique person, individual treatment plans are developed to take into consideration each child's problems, deficits, needs, and strengths.

- 1 -

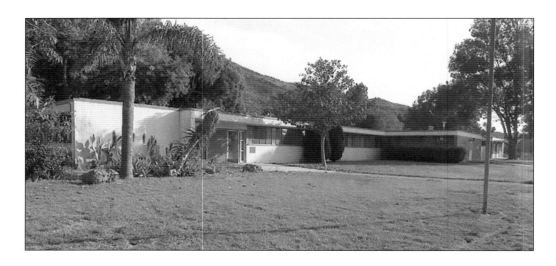

The Rieger building (above), built in 1955, housed the children's new administrative offices. At the former unit, the boys' ward consisted of two dormitories, a day room, and a courtyard. The girls' ward entailed two dormitories, a sitting room, a music room, a playroom, and a kitchen. Three psychiatrists, two social workers, one psychologist, and three teachers were assigned to the children, who received little formal instruction. In 1958, under Dr. Norbert Rieger, the staff consisted of four psychiatrists, four social workers, a psychologist, an occupational therapist, a recreational therapist, and nursing personnel. One hundred twenty children were housed in eight residential cottages (below), with access to five classrooms, occupational therapy facilities, a gymnasium, an outdoor swimming pool, a home economics classroom, and an audiovisual educational room. (Above, courtesy MS; below, courtesy CSUCI.)

In 1960, two psychiatric technicians, John Hoopingarner and Bill Libby from Unit 13, the boy's unit, began an activity program in their day room, dubbing it the "Lucky 13 School." There were approximately 85 patients, ages 8 to 28, who were separated from the Children's Unit. Empty portable buildings were utilized, as well as a temporary building near the auditorium. Hoopingarner and Libby brought various forms of arts and crafts into the classroom. "We figured treating the kids nice couldn't hurt them," Libby said. In 1965, they acquired teacher Earl Carter and employed adult clients as teaching assistants, along with psychiatric technicians. By January 1966, there were six teachers on staff, a formal library, and later, the girls were placed in the same division as the boys. (Both, courtesy CSUCI.)

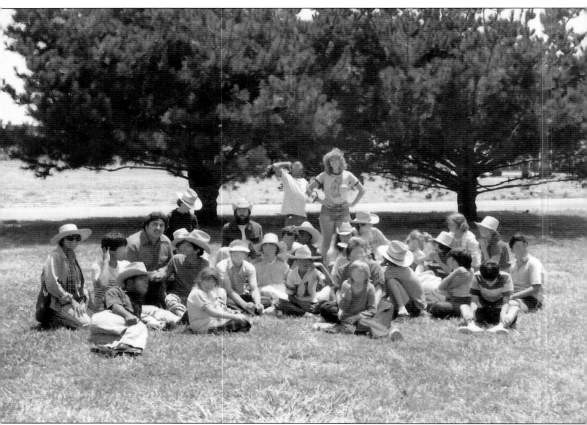

Until 1955, the adolescents, like the children, were mixed in with the adult population. This was done to promote a "grandmotherly" or "grandfatherly" effect. Assistant superintendent Louis Nash felt strongly that the adolescents should have their own separate program and by August 1968, four units and an accredited high school, which later came to be known as the Louis R. Nash High School, were established for students aged 15 to 19 years old. It was later reformulated into three coeducational residential units: one for non-psychotic teenagers with severe acting-out behaviors, one for psychotic and severely neurotic teenagers, and the last for less mature, more fragile teenagers. Developmentally disabled clients were not treated in this unit. Students were placed into groups based on levels of academic aptitude, aggression, self-image, self-motivation, and socialization skills. Along with the standard classes, the curriculum included art, typing, foreign language, home economics, driver's education, industrial education, and physical education. The goal was to enable them to graduate or reenter society to complete their graduation. In 1970, the units became coeducational. (Courtesy Susan Gransee.)

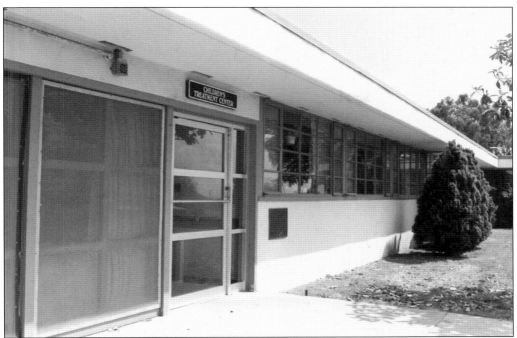

Mountain View School, seen here around 1970, simulated any typical elementary or secondary school. In 1967, the hospital became Camarillo State Hospital and Developmental Center, and with that new emphasis, "programs" were created out of the existing units (for example, children and adolescents became Program 5). In 1971, individualized programs for autism, the developmentally disabled, and the mentally disabled were established. Developmentally disabled clients under 23 attended the Marian Craig School, named after a former social worker. The DMH (Deaf Multi-Handicapped School) became the first sensory deprivation program for the hearing and visually impaired in the state system. Classes concentrated on skills of motor development and language to eye-hand coordination to reading, math, and science. Students learned to tell time, make change, and balance a checkbook. The staff even inserted a speaker into a stuffed Snoopy dog to help them communicate and teach. (Above, courtesy MS; below, courtesy CSUCI.)

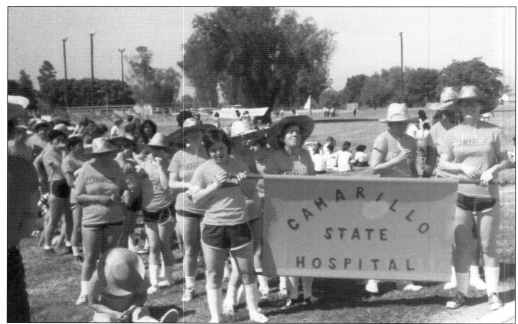

The Children's Center (boys 7–15, girls 7–17) provided a structured environment, with a family-like atmosphere. Approximately 85 percent had a history of violent behavior but did not suffer from severe physical, sensory, or neurological deficits. Each child had an individualized educational program, which also accommodated the needs of each age group and condition. Young boys had their own Cub Pack, while older children were involved in a variety of activities, such as coed sports, choir, plays, and even a school newspaper. Ages 13–15 (boys 15–17 were housed and schooled separately) were enrolled in a prevocational job readiness program, where they learned age-appropriate work habits and skills in on-the-job settings. Children enjoyed an indoor swimming pool, basketball court, playground equipment, a gymnasium, and golden retrievers Echo and Echo 2, brought in by psych tech Dee Press. (Above, courtesy Suzan Barosso; below, courtesy CSUCI.)

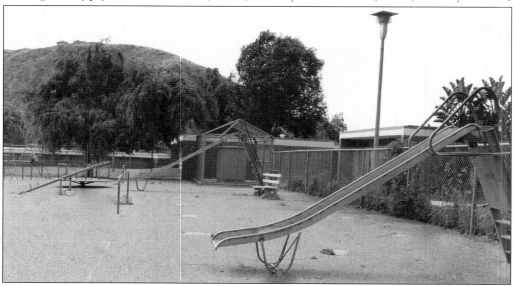

In 1981, two reeducation homes were added. Children lived in a home-like setting, attending school, while involved in community-oriented services throughout the week. Children at the reeducation homes went home to their parents every weekend, while children living within the center's cottages went home on a contingency basis. Adolescents (15–17) were housed in five units, either male or female. This program was coeducational, and it was the first program in the hospital to do so. Education was a priority, with three periods of school in the mornings and two in the afternoons. Special education classes were usually small with six to eight students. The program included a psychiatrist, a psychologist, two social workers, a rehabilitation therapist, nursing personnel, foster grandparents, psychiatric residents, and psychology interns. A modern complex, complete with a spacious dormitory for the children, was constructed in late 1990. (Both, courtesy CSUCI.)

The petting zoo consisted of a donkey, geese, goats, guinea pigs, ducks, rabbits, chickens, pigeons, and rats. It began as a "pet" project in 1981 with a conjunctive effort by Camarillo and Moorpark Community College's exotic animal training and management program. The zoo was made possible by parent and staff support and Moorpark's willingness to supply the animals with supervision by two advanced students. "Once you set even the most aggressive child down with a cuddly animal, that child will just sort of glow all over," commented Jerry Scheurn, of volunteer services at the hospital. Donations paid for the feed, while the compound was built by Moorpark students and hospital children from scraps and surplus materials. "If we've had any complaints so far," Scheurn said, "they are from adults who wonder why the program isn't available to them." (Courtesy MS.)

For several years from the late 1960s to the mid-1970s, the hospital celebrated the fall with a variety of Harvest Festival events that engaged the local community. The Louis R. Nash Memorial High School and Marion Craig School offered weeklong activities in conjunction with the Salvation Army; local city governments; elementary, junior, and senior high schools; and military personnel. There were parades, complete with floats, marching bands, drill teams, clowns, animals from nearby Jungleland, grand marshals, high school queens with their courts, and even the famous Tennessee walking horse, Mr. Millionaire. Exhibiting a fair-like atmosphere, Camarillo provided a variety of carnival-type booths, plenty of treats for sale, concerts, puppeteers, displays, talent shows, informational presentations about the hospital, and open houses to areas on the grounds. (Above, courtesy Sherry Warrick; below, courtesy Suzan Barosso.)

Volunteers were consistent and important players in Camarillo's children and teen development. Las Candelas, for instance, scheduled play days at the children's swimming pool, picnics, and Thanksgiving parties complete with Puritan hats, while the Navy's Yards and Dock Supply Office furnished a special Christmas party with toys and goodies for the children. The young and old, parents and grandparents, students, and the retired offered an assortment of fun activities such as a visit to an ice-cream shop, a park, or even Disneyland. Christmas was especially difficult for the staff because state funds could not be used for holiday parties, so they were very appreciative when visitor Santas mysteriously appeared bearing gifts and treats for the children. (Left, courtesy Howard "Buster" Smith; below, courtesy Sherry Warrick.)

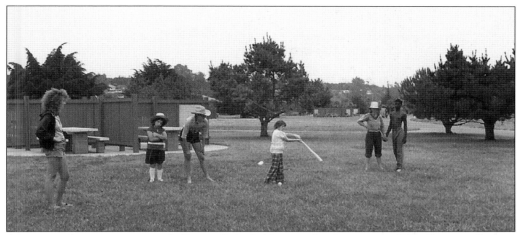

A variety of organizations took Camarillo's children under their wings. The Humane Society brought puppies, the Camarillo Children's Guild supplied puppets, and the Emotionally Disturbed Children's Guild delivered indoor and outdoor play equipment. Marines and Friends 4 the Camarillo Kids joined the children twice a month for ballgames, board games, and barbecues, while the Marine Corps League visited the hospital every other Saturday, teaching youngsters marching and cadence and other games and sports. Children and adolescents engaged the public with theater productions of *Oliver!* and exhibitions of artwork. There were parent groups specifically interested in the welfare of the children at Camarillo. One Western-themed private fundraiser featured jockey William Shoemaker and actor Iron Eyes Cody. Parents and Friends of Mentally Ill Children, Inc., headquartered at the Walt Disney Music Company, held benefit dinners and Christmas card sales. (Above, courtesy Susan Gransee; below, courtesy Suzan Barosso.)

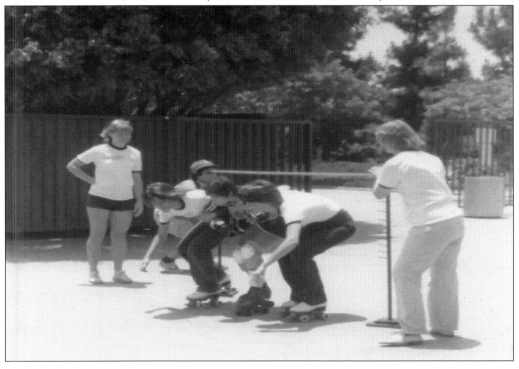

In the early 1970s, California Lutheran College in Thousand Oaks developed a graduate program to train childcare specialists, one of the first in its kind in the nation, combining seminar study with clinical applications at Camarillo in a full-time, 24-month program. Students spent 40 hours a week at the hospital, with 75 percent of their time spent in participation at the Children's Unit and the remainder in class sessions. Their teachers were hospital staff. At the same time, a similar program was ongoing for an associate degree at nearby Moorpark Community College. Students enrolled in speech and language training, family counseling, recreational therapy, motor perception training, and academic teaching. Just a few years later, a six-year program was developed with cooperation from California Lutheran and Moorpark, wherein students could obtain a bachelor's degree as a child-care practitioner after six years of combination study. The program sought to deter the compartmentalized treatment of children. (Courtesy CSUCI.)

Five

CAM-A-LOT
FUN AND GAMES AT THE HOSPITAL

In 1969, the John Robert Powers School (founded in 1923) introduced the adolescent girls of Camarillo to modeling and charm classes. They traveled to Los Angeles, where the school's students and staff created a gala fashion show, with donated clothes and makeup for the girls to model on an elaborate runway. (Courtesy Mary E. Holt.)

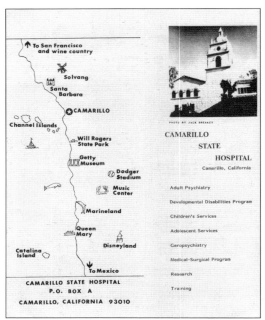

The hospital was nestled between two major points of access to the California coast. Highway 101, at 807 miles, is one of the longest routes in the state, and, according to Daniel P. Faigin of *California Highways*, Pacific Coast Highway 1 is 655 miles "of beautiful beach scenery." Its remote and beautiful location was certainly a drawing point to those volunteering to attend its acclaimed drug and alcohol programs. (Courtesy CSUCI.)

Staff enjoyed celebrating the holidays as much as the patients did. In 1977, they arranged for a Halloween parade and carnival, complete with a high school marching band and lots of fire trucks. Over 250 community members participated, including high school students, grand marshal Mayor Rod Moore of Camarillo, hospital executive director Clinton Rust, and of course, Miss Camarillo. (Courtesy Susan Gransee.)

As much as the hospital staff enjoyed having fun and hosting events for their patients, they were continually preparing them for life outside the hospital. Camarillo, in conjunction with the San Fernando Valley Mental Health Association, conducted a pilot project in 1965, one of the first of its kind in the nation, whereby patients lived and worked outside the hospital. They lived in an apartment building under the supervision of a nurse, who assisted them in the simple routine responsibilities of normal living. In 1971, a new management structure established treatment programs organized by individual needs. The hospital appointed its first executive director in 1976 and, in 1983, initiated Activity Centers, which provided treatment away from the living units. Patients (now "consumers") attended therapy groups, activity groups, and educational programs during the day and evening. (Above, courtesy Suzan Barosso; right, courtesy Sherry Warrick.)

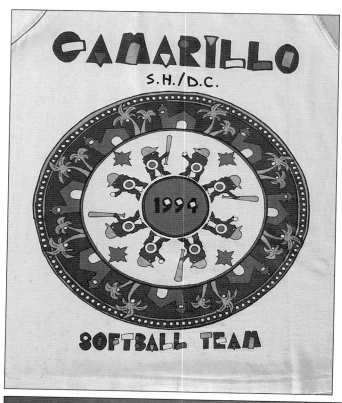

In 1975, Michael Greene became the first hospital representative ever to participate in the International Special Olympic Games held Michigan, where he participated in the softball throw. Michael won third place at the semifinal state games, held earlier at UCLA, which propelled him on to Michigan. Continuing the trend, the state hospital's employee softball tournaments began in 1977, with Camarillo hosting the first year. The tournaments then rotated to other participating state hospital home fields, such as Atascadero Hospital, as pictured here. Camarillo won the first year and the last year it participated (1996). (Both, courtesy Morley Hense and Martha Hense.)

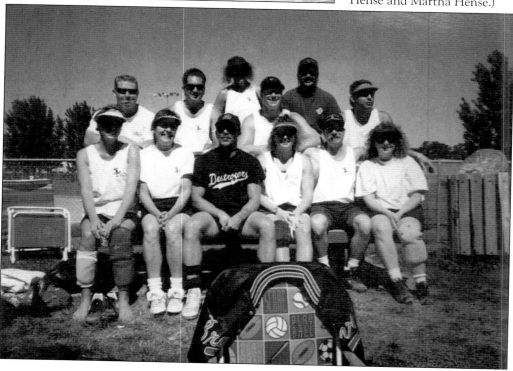

In 1956, the hospital's bowling alley was constructed. It consisted of four lanes, all manually operated. The staff controlled the lanes, while the patients acted as the pinsetters, or pinspotters, who manually reset the bowling pins to their correct position, cleared fallen pins, and returned bowling balls to the players. In 1963, a new patient rehabilitation program was implemented, in conjunction with other confidence-building classes, which encouraged approximately 20 handicapped patients to gradually walk up to the lanes and roll the ball with the assistance of therapists. Once wheelchair-bound, many were able to throw strikes and spares with regularity. (Above, courtesy Mary E. Holt; right, courtesy CSUCI.)

In January 1935, hospital employees participated in their first bowling series against the Oxnard Juniors, winning both games. Much later, the hospital's union sponsored both a slow-pitch baseball team and a bowling team in local leagues, both named "the Independents." There were approximately 10 or 12 bowling teams with four or five members each. The teams consisted of a wide variety of staff and administrators, promoting lots of interaction and comradery between individuals who might not have otherwise met. Sometimes, employees formed individual teams (not associated with the hospital) to bowl in statewide tournaments, taking home trophies for the glory of Camarillo. (Left, courtesy CSUCI; below, courtesy Anthony Casello.)

Steve Axtell, the artist who painted many of the murals at the hospital, was a puppeteer, ventriloquist, and a psychiatric technician, who worked with developmentally disabled and autistic adults. He also taught behavior modification to the staff while participating in an experimental project referred to as the "Teaching Homes," where autistic individuals lived in a natural home environment to help them transition to the outside community. Before Axtell was an employee at Camarillo, he worked at Atascaero State Hospital located in Northern California. Superstar Chuck Berry came to the hospital and Steve's band, Brandywine, played the concert with him, with Axtell on keyboards. Axtell painted Chuck Berry, (right), and "Hotel Camarillo" below, creating the hospital's Walk of Fame, North Quad. (Right, courtesy Steve Axtell; below, courtesy Ben Hipple.)

Although the North Quad was famous for its murals, they were actually located in every area, from the patient dining room in the South Quad to courtyard walls at the RT Building, painted by various artists. As of August 1996, Camarillo's population was 866, the annual cost per capita was $104,390, total acreage was 750, and its licensed bed capacity was 1,397. There were 20 physicians, 31 social workers, 42 teachers, 22 psychologists, 35 rehabilitation therapists, 820 nursing staff, and 4 chaplains, among others. The average employee's years of service was 14.25 years. The average employee age was 43.5. Total salaries/benefits paid was $80 million. Total annual facility operating expense was $4 million. Volunteer hours provided by the community to Camarillo was 6,500 per individual, 1,700 hours per month for groups, for a total of 8,000 hours per month. (Above, courtesy Evelyn S. Taylor; below, courtesy Ben Hipple.)

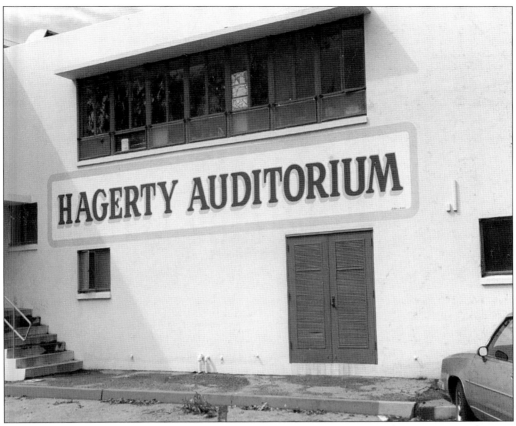

The hospital encouraged its patients to explore and share their creative side, using an inside stage in the Hagerty Auditorium on the South Quad and an outdoor one in the North Quad. The 1991 hospital rock musical *Aliens in the Cactus Garden*, about a patient who, with the assistance of two space aliens, learns about self-reliance, self-discipline, and self-esteem, was actually just one of many creative endeavors by musical therapists Laura Kanofsky and Hank Wadsworth, who produced similar productions since 1984. The pair cast 12 developmentally disabled patients in the show, ages 14 to 57, who performed it before 300 of their peers. (Courtesy CSUCI and Judy Lucas.)

As early as 1955, patients at Camarillo participated in art therapy, which included exhibiting their creations at their Annual Festival of the Arts. The event featured not only artistic works created at the hospital but also those from college and university art departments and individuals. Mosaics, paintings, drawings, ceramics, and sculptures were among the displayed for viewing by 5,000 patients and hundreds of visitors. This grand celebration included instrumental concerts by the Ventura Student Symphony, a brass ensemble from the University of Southern California, the Romany Chorus of Santa Barbara, and choruses from local grade and junior high schools. The Literary Teas from the Oxnard Public Library was also a favorite. (Both, courtesy CSUCI.)

Camarillo offered an art program to build self-esteem and encourage self-expression. From sculptures to ink drawings to paintings, patients took 15 classes per week. They displayed their works at the lobby of a local theater, the second floor of a bank building, the county fair, and even at Department of Developmental Services headquarters. Patients presented artwork in their new gallery in 1994, the first exhibit of its kind, fittingly named "Art Equals Life." During the first month, over 30 pieces sold; in fact, actor Cheech Marin purchased two on the first day. The gallery exhibited as many as 700 pieces at one time. Art therapist Jack Cheney believed that the program allowed patients to articulate their thoughts in their chosen projects: "For all that is wrong with them, there is an awful lot that is right. We want to focus on that." (Both, courtesy CSUCI.)

EL CAMEo

Volume V No. 10 Camarillo, California May 17, 1953

ART FESTIVAL A SUCCESS

The Third Annual Festival of the Arts at the Camarillo State Hospital closed Saturday night, May 10th with a concert of folk songs presented by The Clarions.

The Festival, which has gained increasing acclaim throughout the tri-county area, covered a very wide range of art exhibits and musical programs. The Art Exhibit of paintings, drawings, prints, mosaics, mobiles, ceramics and sculpture was seen and enjoyed by over 5,000 patients from Camarillo State Hospital and several hundred visitors from Southern California.

Schools which contributed to the Festival are The Immaculate Heart College of Los Angeles, the University of Southern California, Los Angeles and Ventura College. Each of these schools sent a wide range of exhibits representing the work of their art departments. There were also contributions by over twenty individual artists who showed from two to fifteen paintings. Several sculptures by Wm. Robsler and some fine photographs by Camarillo Nursing Supervisor Kenneth McGinnis were among the features of the Art Exhibit.

The series of special programs showed three 'firsts' for the Festival just concluded. The concert by the Ventura Student Symphony on Saturday afternoon, May 10th, represented the first concert by a symphony orchestra in the Hospital's Outdoor Theater. Sunday afternoon, May 4th, saw the arrival of the Brass Ensemble from the University of Southern California. This concert also was the first of its kind at the Hospital. The concluding concert of the series, which was held at 8:00 P.M. Saturday, May 10th in the Women's Dining Room, represented the first full concert in the Festival series devoted exclusively to folk music.

One of the most interesting aspects of the special program series presented in connection with the Festival of the Arts is the number of groups and individuals who return year after year to present programs. One such group is the Rowany Chorus of Santa Barbara which has a large and enthusiastic following among patients and employees of the hospital.

Con't. Page 2

The Literary Teas presented by Miss Emily Kitchen, librarian of the Oxnard Public Library, have become an annual 'must' in the series. In the same class also appears the chorus and dance group from Ventura College.

The annual Duo-Recital by Mr. John Crown, pianist, and Mr. William Vennard, bass, of the University of Southern California was again one of the high points of the series. This year they performed to a 'standing room only' audience. The 1953 Festival series attempted to present a complete range of programs from educational institutions of all levels. An elementary school group from Weiner's Oaks, Haydock Junior High School of Oxnard and the Ventura College represented the public schools in the local area.

The appearance of Mrs. Joseph Warrick in an organ concert on Friday afternoon, May 9th, marked the third year in which an organ recital has been a part of the Festival. The appearance of Dr. Louis Woodson Curtis with a showing of his delightful travel films was a new feature for the Festival series although Dr. Curtis has given other showings to patient groups within the hospital.

The Festival of the Arts represents a concentrated effort on the part of the Rehabilitation Department of the Camarillo State Hospital to bring as wide a range of art experience as possible to the patients of the hospital. This is only possible through the splendid cooperation of artists and musicians from all of Southern California, who freely give of their time and talents to the project.

'A FOWL STORY'

Here's one for the 'birds', and naturally enough it concerns two of our little feathered friends who have established a home on the window sill of Ward II-A's shower room.

About 3 weeks ago these two baby birds started building their house on a very well situated lot overlooking a Camarillo playpen on one side and bordered on the other by the driest shower room on the CSH campus. Their house is the conventional one story ranch type with the back screened in and the front enclosed with obscure glass. The design affords the utmost in ventilation and privacy that all honeymooners desire.

The 'love-birds' moved in almost at once, and almost at once things began to happen. These birds started housekeeping with the future in mind, by starting a 'nest-egg', and by the end of the first week they had two eggs in the nest. Now I'm no member of the Audubon Society, but I thought this quite remarkable in respect to the time element. These birds went on to set some kind of ornithological record because by the end of the second week there were five eggs in the nest and it began to look like the poultry concession at the Farmers' Market.

Well, I guess these 'love-birds' decided that five was a crowd and on Thursday, April 17, little Mother Bird was blessed with a chick, and at last report both were doing fine.

WARD NEWS

Ward 8 held a dancing party in the Women's Dining Room Annex on Saturday, April 19th for its members and guests from different men's wards. 7A men helped arrange tables and chairs. Mrs. Book, Mrs. Rozelle, Mrs. Stickler and Mrs. Kirby assisted in preparing colorful decorations and in serving coffee and cake to guests with the help of a ward committee composed of Jackie F., Carolyn G., Dorothy B., Dorothy J., Geneva T., Charlene D., and Mrs. Joan L. A waltz contest was held and was won by Charlie G. and Willie Marie C. A jitterbug contest was won by Sondra H. and Tommy D. Robert T. won the door prize. Among the guests were Mr. and Mrs. Marshall and Mr. and Mrs. Stickler. A gay and charming time was had by all.

Joyce F. of Ward 2 reports that the Las Amigas Club was assigned a building in the Hut Village for recreational and craft purposes on April 4th. The girls will largely supervise their own activities. This is patient participation fully expressed and is deeply appreciated by the ward members.

Art classes will begin at the hospital shortly, under the direction of Barbara S. and Claire R. A writing class is also contemplated.

Celebrities were always avid supporters of Camarillo's children. Nanette Fabray spoke at a volunteer luncheon, while Fred MacMurray facilitated a Christmas delivery of toys. Early members of the charity Thalians included Hugh O'Brian, Gary Crosby, Rita Moreno, and Gene Barry. Founded by Hollywood actors and actresses in 1955, the Thalians remain dedicated to mental health causes. (Courtesy CSUCI.)

For five hours per day, autism patients received speech and language services, sensory integration, and rehabilitation and music therapy. The program also utilized the Pre-Vocational Activity Center to teach work habits and social skills for possible reentry into the outside community. Two teaching homes served as transitional facilities. The program accepted patients of all developmental levels over 14. (Courtesy CSUCI.)

Early on, television was not only entertainment for the 7,500 patients at the hospital but was utilized for treatment as well. In 1962, a closed-circuit television system was installed, wherein patients appeared on their own shows, gathered news, wrote scripts, and built sets. They also had control room responsibilities, such as handing cameras and sound equipment, and acting as lighting director or make-up person. It was the only such project in the nation, with a staff of 40 and 300 patients. Channel 6 programming ranged from quiz shows to newscasts, transmitted from the auditorium and the studio, courtyards, and administrative areas. Volunteering for this project was Jack Warner Jr., son of Warner Bros. studio cofounder Jack L. Warner, who persuaded Hollywood studios to provide the station with valuable technical equipment. Producer-writer-director Ira Rosten explored the project in an hour documentary for Los Angeles station KTLA. The theme song for the hospital station, as selected by the patients, was "Let's Get Away From It All." (Courtesy CSUCI.)

Poetry was another creative method that young patients utilized to share their private feelings, gaining confidence as they realized that they were not alone in their feelings of isolation. Writers in the hospital's poetry classes from the Arts Therapy/Fine Arts Discovery Program recited their prose at special readings open to the public, where attendance numbered over 100. Launched in September 1994, the classes provided teens with a new way to speak out. Jeff Grimes, a Ventura poet who taught in the arts and mental health therapy program, stated, "The fact that they are institutionalized gives them less of a voice." The four classes of 8 to 10 students met once a week, publishing anthologies featuring more than 100 poems. "I never had a really good time in my life. I know I'm not a loser but sometimes I'm not a winner. It's been like that since the beginning," wrote one young patient. (Courtesy Mary E. Holt.)

Staff often took athletes from Program 9, the habilitation program, to outings, such as the Lake Tahoe Winter Olympics, pictured here. Counties that had a state hospital with developmentally disabled residents and a Special Olympics program were not included within their county's Special Olympics. Hospital Special Olympics areas had their own directors, along with their own colors and uniform styles. Camarillo's colors were blue and gold. (Courtesy Suzan Barosso.)

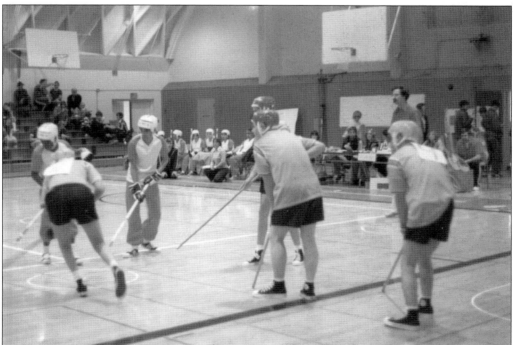

The hospital's Puck Stompers formed its Special Olympics floor hockey team in 1977, the only floor hockey team in Ventura County at the time. The team played in four tournaments in eight months since its inception, practicing twice a week for three hours. Fans consisted of fellow patients who cheered their team with purple and gold pompoms. (Courtesy Suzan Barosso.)

Rehabilitation specialists were always challenging their patients with fun physical education exercises. The developmentally disabled starred in their own exceptional events during the annual Mt. Olympus Games, sponsored by the Program for the Mentally Disabled. Approximately 150 participated in games of basketball shooting, 440-yard run, 50-yard dash, chin-ups, gunny sack race, three-legged race, tug of war, and of course, a water-balloon toss. The activities prepared them for the upcoming preliminary Special Olympics events, held at varying state hospitals, before moving on to the official California Special Olympics. The games also socialized the patients by encouraging them to communicate and connect with others. (Above, courtesy Suzan Barosso; below, courtesy CSUCI.)

If a picture is worth a thousand words, then fun and laughter were always the best medicine at 1878 South Lewis Road in Camarillo. Staff and volunteers often provided female patients with grooming sessions regarding hair, nails, makeup, and even fashion, with the hope that they would "feel like a lady again," as one patient expressed it. After the hospital closed, some staff opened up their homes to their former patients. (Courtesy Sherry Warrick.)

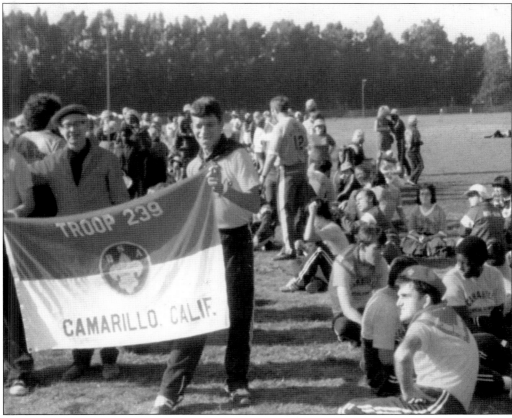

Camarillo's charter with the Boy Scouts of America, Troop 239, began in 1968. Although technically their ages (all scouts were over 21) disqualified them from traditional membership, they participated in numerous activities, including training in basic first aid, creating hospital floats for city parades, clearing cactus from hospital land, camping in the wild, and joining other troops in gatherings throughout the county. (Courtesy Suzan Barosso.)

In 1995, Camarillo State Hospital served a population of approximately 495 developmentally disabled consumers and 394 mentally disabled residents. At this time, a new individual program plan was introduced, "Enhancing Independence Through Innovation." The goal was to stabilize individuals and return them to their community, with the highest level of independent function possible. As vocational services director Virgie Yates, an employee since 1949, explained, "We give them on-the-job training in the paint shop, the upholstery shop, stores, the laundry, on grounds keeping, to try to get as near as possible to those things they could do in the community," he said. (Both, courtesy CSUCI.)

In celebration of the hospital's 50th anniversary, a group of young patients known as the Camarillo Chorus Line performed on the city's community center stage. The group's performance was part of a weeklong series of events commemorating the anniversary, including an official party, hospital tours, and an expedition softball game. In 1996, approximately 500 employees (past and current) attended the 60th anniversary of Camarillo's initial opening; however, this was a much more somber occasion, as it was known that the hospital would close in just a year. At this time, Camarillo's programs for the mentally disabled included Program 2, Adult Psychiatric Rehabilitation Services; Program 5, Youth Services; and Program 6, Gero-Psychiatric/Acute Medical Surgical Services. Its developmentally disabled programs include Program 8, Learning/Sensory Development; Program 9, Behavior Therapy and Social Learning; and Program 10, Behavior Development and Learning Center. (Both, courtesy CSUCI.)